The DK Art School

AN INTRODUCTION TO
OIL PAINTING

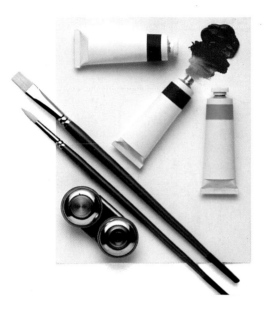

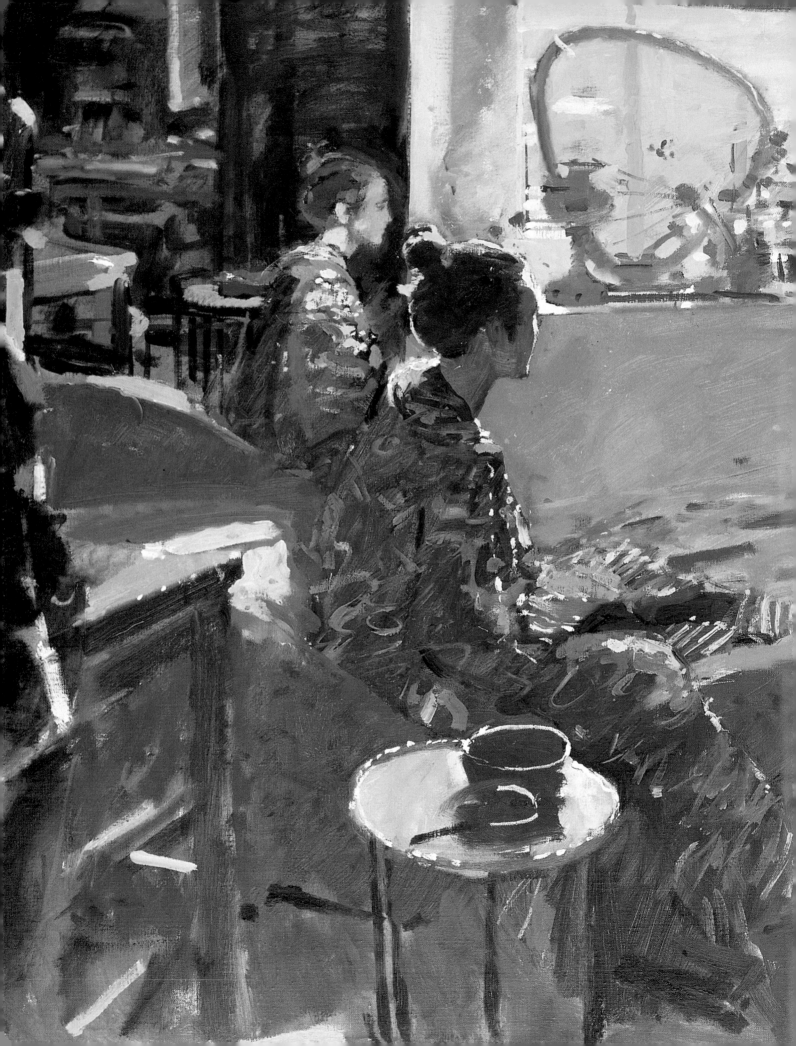

The **DK** *Art School*

AN INTRODUCTION TO
OIL PAINTING

RAY SMITH

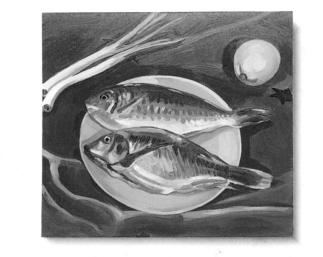

DORLING KINDERSLEY
LONDON • NEW YORK • STUTTGART
IN ASSOCIATION WITH THE ROYAL ACADEMY OF ARTS

A DORLING KINDERSLEY BOOK

Project editor Susannah Steel
Art editor Heather McCarry
Designers Dawn Terrey, Stefan Morris
Editorial assistant Margaret Chang
Series editor Emma Foa
U.S. editor Laaren Brown
Managing editor Sean Moore
Managing art editor Toni Kay
Production controller Helen Creeke
Photography Phil Gatward, Jeremy Hopley

www.dk.com

First American Edition, 1993

2 4 6 8 10 9 7 5 3

Published in the United States by
Dorling Kindersley, Inc., 232 Madison Avenue
New York, New York 10016

Published in Great Britain by Dorling Kindersley Limited.
Distributed by Houghton Mifflin Company, Boston

ISBN 0 7894 3289 7 PB

First paperback edition 1998

Library of Congress Cataloging-in-Publication Data
Smith, Ray, 1949-
 An introduction to oil painting / by Ray Smith. -- 1st American
ed.
 p. cm. -- (DK art school)
 Includes index.
 ISBN 1-56458–372–4
 1. Painting--Technique. I. Title. II. Series.
ND1500.S57 1993
 751.45--dc20 93-19076
 CIP

Color reproduction by Colourscan in Singapore

Printed in China
by Toppan Printing Co., (Shenzhen) Ltd.

CONTENTS

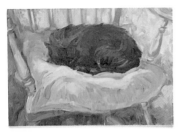

CHARACTERISTICS OF OIL PAINT

ONE REASON WHY OIL PAINT has been so popular for hundreds of years is that it is an incredibly versatile painting medium that can be manipulated in many ways. Oil paint is so responsive because it dries slowly, allowing for colors to be modified and moved around on the surface of the painting for some time after they have been applied. This aspect of oil paint makes it an excellent medium for alla prima painting methods (pp.52-53), in which the paint itself can accurately reflect the immediacy of the artist's response to an image. Once oil paint has dried, it can be overpainted in a number of ways without disturbing or dissolving the original color beneath. This means that a complex layer structure of paint can be built up to create different effects.

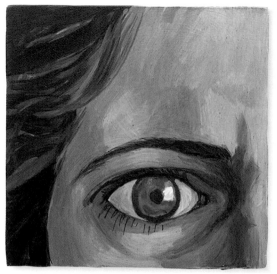

A smooth board is overlaid with thin layers of transparent color

Changing the texture of oil paint

If oil paint is used directly from the tube, it can be painted thickly with bristle brushes in a rich, impasted style. It has sufficient body to hold the crisp shape made by a brushstroke or a painting knife, whether that shape is urgent or delicate. This can give painting a real sense of directness and establish an immediate link between the style of the painting and the artist. Oil paint can also be thinned down slightly to a creamy consistency, and brushed out to an enamel-like smoothness. If it is diluted very thinly with turpentine, or white spirit, the consistency of the paint is ideal for sketching a composition, or if mixed with an

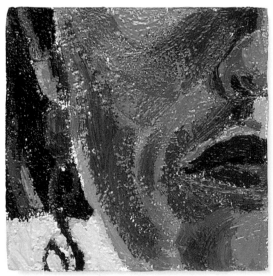

This rough board emphasizes the thick strokes of rich color

oil painting medium it can be formulated as a glazing color. The painting medium enables the glaze to become a transparent stain that modifies the appearance of a color beneath. Oil paint can be used "stiffly," or unmixed, to create textured dry brush and scumbled techniques (pp.26-27) with bristle brushes, or it can be used in smoother manipulations with soft hair brushes. Of all the painting media, oil paint is the one best suited to blending techniques, in which one color or tone can be made to fuse smoothly and almost imperceptibly into another.

The qualities of oil paint

One characteristic of oil paint that differentiates it from other media is its richness and depth of color. This is because the pigments are ground in a drying oil that has a relatively high refractive index (the amount of light it reflects and absorbs). Chalk that otherwise appears opaque white becomes practically transparent when it is mixed with linseed oil. Pigments vary in their refractive index, which to a large extent dictates whether they appear transparent, semi-opaque, or opaque in oil. When compared to other media, oil paints are the most successful at exploiting the different qualities of opacity and transparency. Over a pure white ground, for example, a thin layer of a transparent oil color has a saturation and depth that is difficult to achieve in any other medium.

Creating different effects with oil paint

The four studies shown here demonstrate some of the characteristic effects of oil color, used in different ways on a variety of surfaces. The smooth board on the top left-hand side provides a hard, untextured surface on which the brushstrokes remain clearly visible and unblended. A thin, warm transparent glaze, painted over the various colors, deepens the tone of the portrait and makes the face appear more cohesive. The bottom panel on the left is a rough surface on which thick paint has been applied as impasted brushstrokes. The uneven texture of this surface automatically affects each brushstroke, and as a result, the style is much bolder and chunkier. The top right-hand section is a rough canvas that has been prepared first with a single tone of one color, applied over the whole surface and then left to dry. This colored canvas is visible between areas of paint on the face and hair, so that the canvas and paint appear to be integrated as one surface. Paint has been applied with a dry brush technique that picks up the ridges of the rough canvas, while scratches (known as sgraffito) on the hair have been made with the end of a brush handle. The bottom right section shows a smooth canvas over which paint has been carefully blended. Different tones and colors have been painted as areas of light and shade, and then blended together to create a smooth transition between colors.

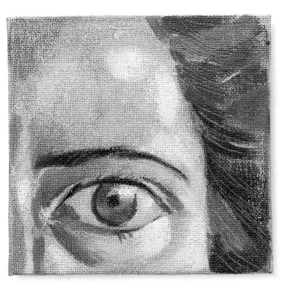

A rough colored canvas gives these dry strokes of color more texture

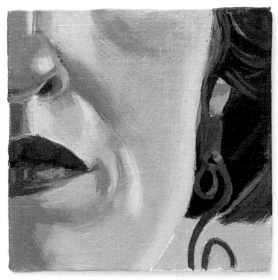

This fine canvas allows individual strokes of color to be blended smoothly together

7

A Brief History

THE DEVELOPMENT of oil paint as the most common medium for painting in Europe evolved slowly in the fifteenth century. Before this, a popular medium for painting on panel had been egg tempera, but it did not have the flexibility of pigments bound with a drying oil. Oil paint also had the capacity to be blended and manipulated on the surface of the painting, and its transparency allowed for a far greater range of tones and resonant colors.

THE TRANSITION from egg tempera to oil paint in Northern Europe, and then in Italy toward the end of the fifteenth century, produced many examples of paintings in which the preliminary work was done in egg tempera, while later stages, such as thin transparent glazes, were applied in oil color. There are also examples of works in which egg and oil are contained in the same layer.

Although the Dutch van Eyck brothers are popularly credited with the discovery of oil painting in the early fifteenth century – Jan van Eyck *(b. before 1395-1441)* made progress developing the oil medium and using glazes – the use of oil-resin varnishes and drying oils is in fact quite well documented since the eighth century. Painters in Italy began to copy the Netherlandish way of modeling the underpainting in opaque colors, and then applying rich transparent glazes.

The progress of oil paint

Fifteenth-century Italy saw artists such as Piero della Francesca *(1410/20-1492)*, whose early work is predominantly in egg tempera, coming to terms with the new oil medium. In Venice, Giovanni Bellini *(c.1430-1516)* began to exploit the depth and richness of tone and color that could be had with oil

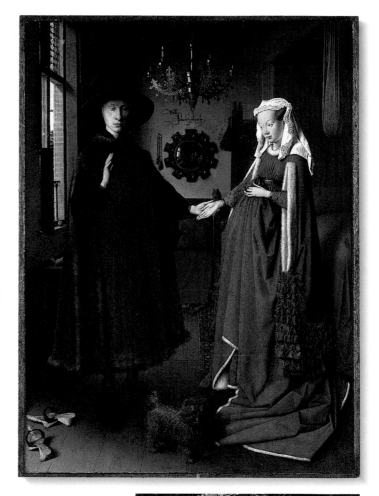

Jan van Eyck,
The Arnolfini
Marriage, **1434,**
32¼ x 23⅛ in (82 x 60 cm)
Oil has been used in this most famous of 15th-century portraits, though there may be egg tempera in the underpainting. With this new medium, van Eyck achieved an extraordinary range of tones, with deep shadows and clear bright lights.

painting. He often worked first on an egg tempera underpainting, with its characteristic cross-hatched modeling, but the use of oil in the later stages of painting gave his figures an almost tangible existence. Perugino *(c.1445/50-1523)* and Raphael *(1483-1520)* were among other artists of the time working in both media. Raphael sustained the purity of the whites and blues in his skies by using the less yellowing walnut oil as a binding medium, rather than the linseed oil he used with other colors. By the

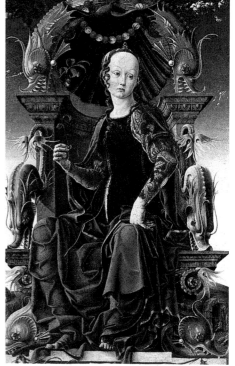

Cosima Tura, *Allegorical Figure,*
mid-15th century *45¾ x 28 in (116 x 71 cm)*
Said to portray one of the Muses, this Italian work was painted initially in egg tempera and then extensively remodeled in oil. Transparent glazes enrich and deepen the colored drapery.

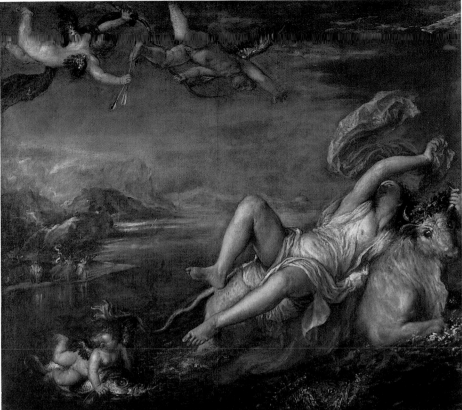

Titian, *The Rape of Europa,*
1559-62 *73 x 81 in (185 x 206 cm)*
This painting shows Titian moving toward the very loose style of his last paintings, where fluidly modeled forms in opaque colors are overpainted in transparent glazes. The work is alive with movement, with the turbulent figure of Europa echoed in the twisting figures above.

first decade of the sixteenth century, oil paint had become universally established as the prime painting medium in Italy.

It is with later Venetian painters, such as Titian *(c.1487/90-1576)*, and then Tintoretto *(1518-94)*, that we see a freeing up of composition and expression. That these artists were now using oil paint exclusively had much to do with this new freedom of expression, for its flexibility allowed them to take a looser approach, not only in initial stages, but throughout the whole painting process.

Economical painting

By the seventeenth century, it was common for painters to work in an economical style on a colored surface that provided the mid-tones, while opaque colors were added for lights, and thin transparent darks for shadows. Artists as diverse in style as Caravaggio *(1571-1610)* and Velásquez *(1599-1660)* used these dark "grounds" to emphasize any areas of high contrast and create dramatic lighting effects.

Rembrandt *(1606-69)* often used double grounds on his canvases, with an underlayer of red bole (clay), or red ochre and a layer of gray or brown on top. His images often seem to be sculpted in relief out of the dark ground. Rubens *(1577-1640)* worked similarly, but often prepared a warm yellow-brown layer that he applied with a bristle brush over a white priming. This underlayer helped him to create images more freely, giving more expression to his painting style.

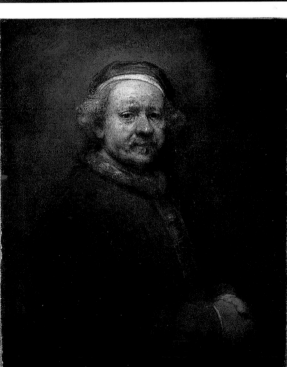

Rembrandt van Rijn, *Self-Portrait*
at the age of 63, **1669** *33⅛ x 27¾ in (86 x 71 cm)*
This painting was made in the last year of Rembrandt's life. The canvas was prepared with a dark brown ground, and the face modeled vigorously using thick Lead White. These impasted brushstrokes give vitality and texture to the face. There is a sense of composure and honesty in this self-portrait, and the sense of gravity is heightened by the flickering shadows that cross his features.

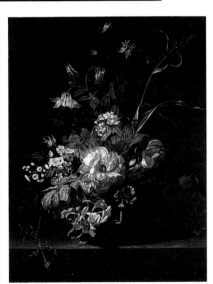

Rachel Ruysch, *Flowers in a Vase,* **c.1800**
22½ x 17⅛ in (57 x 43 cm)
Ruysch was an accomplished and successful still-life painter in 17th-century Holland. She adopted the popular technique of using a red-brown ground as a base, with opaque highlights and transparent darks on top. This ground has the effect of bringing the flowers out of their shadows and into bright focus. Each petal and leaf has been blended with exquisite finesse.

Unusual additions

Oil paintings from the seventeenth to the nineteenth centuries reveal some complex layer structures – and can include complicated materials. The British artist George Stubbs *(1724-1806)* used wax-resin mixtures with a drying oil in certain works. Some artists used what are now recognized as unstable materials; Sir Joshua Reynolds *(1723-92)*, for instance, incorporated oil, resin, and bitumen mixtures into his paintings. Gainsborough *(1727-88)*, on the other hand, generally painted fairly thinly, with a drying oil plus pigment mixtures thinned with a solvent.

Research on paintings from the eighteenth and nineteenth centuries is limited, but what we can learn from the state of many works in this period is that the more straightforward the painting techniques and materials are, the more reliable the results.

A change of direction

During the nineteenth century, many artists rejected the constraints of traditional academic practices and moved toward "plein-air" landscape painting from nature. This, combined with new ideas about color and the discovery and development of new pigments, led to the new movement known as Impressionism. Artists such as Monet *(1840-1926)* and Renoir *(1841-1919)* made paintings that were often no less complex than oil paintings of the past, but were characterized by a sense of freshness and immediacy that was quite new. Now the character and texture of the individual brushstroke was integral to the look of the work. Color became a focus of painting as never before, with new pigments available to artists and a greater use of bright, saturated primaries and secondaries.

The change in attitude and new approach to oil painting that was first initiated by the Impressionists led to further reevaluations during the Post-Impressionist years of Gauguin *(1848-1903)* and Van Gogh *(1853-90)*. The Cubists Braque *(1882-1963)* and Picasso *(1881-1973)*, and German Expressionists Kirchner *(1880-1938)* and Nolde *(1867-1956)*, for example, all used the adaptable medium of oil to make great stylistic and technical changes in art. The Surrealists Max Ernst *(1891-1976)* and Salvador Dali *(1904-89)* both used oil in dramatic new ways. Dali reworked the technique of blending oil into soft fluid forms to give expression to his interior thoughts and subconscious desires, while Ernst unlocked his imagination and invented or adapted techniques to give complex textural starting points for his works.

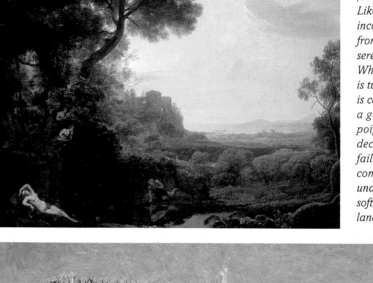

Claude Lorraine,
Echo and Narcissus,
1644 *46½ x 37¼ in (95 x 118 cm)*
Like Titian, Claude incorporated stories from Ovid into his serene landscapes. While Titian's work is turbulent, Claude's is calm, suffused with a golden light. The poignancy of self-deception and the failure of human communication is underscored by this soft, warm Arcadian landscape.

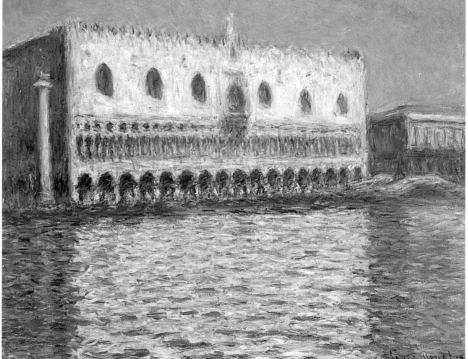

Claude Monet, *The Ducal Palace at Venice,* **1908** *32 x 38½ in (81 x 98 cm)*
Monet relied on color contrasts to create the brilliant effects of light. Pure yellows and violets and blues and orange-red make this facade glow against the sky and shimmer on the water.

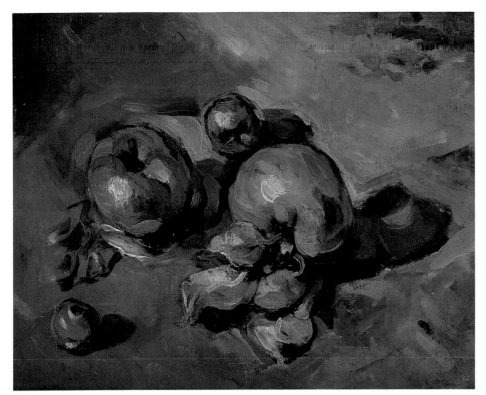

Paul Cézanne, *Green Apples,*
c.1873 *10¼ x 12½ in (26 x 32 cm)*
*Cézanne's work differs from that of the
Impressionists in its adherence to formal
traditions of painting. He was unique in
his use of color and analytical approach to
shapes. The warm orange-brown ground here
contrasts with the cool, striking green apples.*

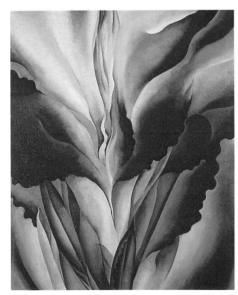

Georgia O'Keeffe, *Red Canna,*
c.1923 *36 x 29⅞ in (91 x 76 cm)*
*This is very different from the cool poise of
Ruysch's work – O'Keeffe's flower is suffused
with hot color and is alive with feeling. The
adjacent colors are simply blended, but
together they form a stunning image.*

Gerhard Richter, *Betty,*
1988 *40⅛ x 28⅜ in (102 x 72 cm)*
*This portrait has a forceful power and intensity.
The immaculate but engaging nature of the
painted surface turns this image into something
precious. In a world of millions of snapshots,
Richter painstakingly retrieves one of them
and asks us to look at it again carefully.*

Twentieth-century style

With oil paint now used and adapted for a diversity of painting styles, its position at the forefront of painting media has been reinforced in the twentieth century. The German artist Gerhard Richter *(b. 1932)* has considered the relationship between painting and photography. His 1960s monochromatic paintings, based on newspaper photographs, exploited the way oil color could be blended. He found a correlation between oil techniques and the smooth, often blurred quality of photographs.

During the most recent decades, many artists have found distinctive ways of working with this painting medium to give us new insights and meanings. Works by the Italian artists Francesco Clemente *(b. 1952)*, Enzo Cucchi *(b. 1949)*, and Mimmo Paladino *(b. 1948)*, although personal and individualistic, give expression to universal needs and aspirations. The cool, powerful works of British artist Lucien Freud *(b. 1922)* demonstrate the impact and intensity that can be achieved by painting directly from life, while the less direct approach of Howard Hodgkin *(b. 1932)* to his subjects has resulted in forceful works controlled by strong, energetic color. Paintings by artists such as Christopher Lebrun *(b. 1951)* appear to draw on myths and images from the past, but they remain utterly contemporary in their engagement with surface, texture, and color. In the US and elsewhere in the world, a number of artists have begun to find inspiration in new forms of abstraction that still draw on the same techniques and traditions used for over five hundred years.

OIL PAINTS

OIL PAINTS ARE MADE BY GRINDING PIGMENTS with a drying or semidrying vegetable oil such as linseed oil, walnut oil, safflower oil or poppy oil. This oil binding medium gives the paint its characteristic appearance and distinctive buttery feel. Pigments ground in oil have a particular depth and resonance of color because of the amount of light the oil reflects and absorbs. The oil also protects the pigment particles, as well as acting as an adhesive to attach the pigments to a painting surface. Commercial manufacturers add to this basic mix to give a range of stable paints with relatively consistent drying times.

Walnuts

Walnut oil
Walnut oil was more popular in the past than it is today, as it is difficult to keep fresh for any length of time. Walnuts contain about 65% oil.

Poppy seeds

Opium poppy plant

Poppy oil
Poppy seeds contain about 50% oil. This semidrying oil is slow to dry in comparison with drying oils such as linseed oil, so to avoid any cracks appearing, ensure it is completely dry before overpainting.

Drying and semidrying oils
The range of drying and semidrying oils used to bind pigments together are made from the crushed and pressed seeds of certain plants. The most important of these plants is linseed oil, which is a golden yellow drying oil and comes from the seeds of the flax plant. The best quality linseed oil is cold-pressed, although most modern oils are hot-pressed. Poppy oil is a semidrying oil made from the seeds of the opium poppy plant. It is a pale straw color and has long been popular as a binding medium for pale pigments that might

be affected by the more yellowing linseed oil. It is popular for alla prima work (*see* pp.52-52) as it takes a long time to dry. This means that the paint can be moved around for some time after it has been applied. Safflower oil from the seeds of the safflower plant is similarly pale and slow-drying, and it can be used in the same manner as poppy oil. Walnut oil from the nuts of the walnut tree was very popular in the past for its pale color, and it has been identified as a binding medium for white and blue pigments in many Renaissance paintings. It should be used fresh, as it goes rancid quickly.

Traditional and modern oil mixes
In the past, artists used a wide variety of ingredients in their painting mediums (below); some caused pictures to darken and crack. Nowadays, a mix of stand (linseed) oil and turpentine is recommended, and very little resin, if any, should be added.

Sun-bleached linseed oil

Copal oil varnish

Black oil

Azurite pigment

Azurite

Realgar pigment

Realgar

Orpiment pigment

Orpiment

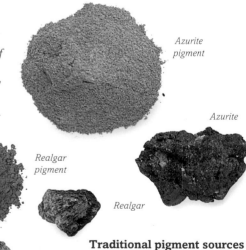

Traditional pigment sources
Traditional pigments were made from natural sources. The mineral azurite was ground to powder and used as an underlayer for Ultramarine Blue. The red and yellow pigments realgar and orpiment are poisonous and no longer available. Synthetic substances now replace many natural pigments.

Oil absorption

If pigment particles were the same smooth shape, size, and weight, they would all need the same amount of oil to coat their surfaces. In fact, each pigment needs a specific amount of oil to reach a desired uniform consistency. Paint with less oil content is less flexible and is liable to crack if you paint it over a color with high oil absorption. This can be avoided using the "fat-over-lean" rule (*see* pp.58-59).

High oil content *(70% or more)*
Pigments include Burnt Sienna, Raw Sienna (above), Burnt Umber, Winsor Blue and Green, Alizarin, Permanent Rose, and Cobalt.

Medium oil content *(50-70%)*
Cadmium Yellow, Cadmium Red (above), Raw Umber, Oxide of Chromium, and Ivory Black are included in this category.

Low oil content *(50% or less)*
Only a few pigments are included here: Ultramarine (above), Manganese Blue, and Flake White.

Mixing oil paints

Making your own oil paints is not difficult. You need a ground glass slab and a flat-bottomed glass muller (these are also available in hard stone, such as granite), a large palette knife, cold-pressed linseed oil, and some pigment powder. Avoid using toxic pigments such as Lead White or Cobalt Blue, as they are too dangerous. You should use a dust mask whenever you grind powder colors.

Materials

Airtight jar

Palette knife

1 ▲ Place a small heap of pigment powder in the center of a glass slab and make a well in the middle of the powder. Then pour a small amount of linseed oil into the well.

2 ◄ Use the palette knife to mix the oil and pigment into a stiff paste. You may find this is easier to do with some pigment powders than with others.

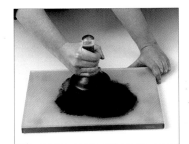

3 ◄ Place the muller on top of the paint mixture and start to grind it with a continuous, smooth circular action. Use the palette knife to scrape any paint from the edge of the muller and the sides of the glass slab back into the middle.

4 ▲ When the paste has achieved a creamy consistency, scrape it off and store it in a small, airtight jar.

Glass slab and muller

Modern commercial paints

Commercial oil paints are sold in tubes, and most manufacturers produce two lines: artists' and students'. Artists' paint is of a higher quality, as it contains the best pigments and has the highest proportion of pigment to drying oil. The price of individual colors largely depends on the cost of the raw material used to obtain that particular color. The wide range of cheap, bright, lightfast synthetic pigments now available are a good option.

Cadmium Red is a lightfast, opaque color that was introduced in the early twentieth century.

Transparent artificial Ultramarine replaced the natural pigments made from lapis lazuli in the nineteenth century.

EQUIPMENT

OF THE EQUIPMENT YOU NEED for oil painting, the most important tools are your brushes, and the look of a painting depends on their quality. There are two main types of brushes: stiff hair bristle brushes made from hog hair, and soft hair brushes made from sable or synthetic material. You also need a certain amount of solvent, such as turpentine or white spirit, to dilute your oil colors and to clean off excess paint. Linseed oil, the basic binding medium for oil paint, can also be used to modify the consistency of colors. You can paint on many different surfaces and textures, but those used most frequently by oil painters are canvases and wooden panels. Keep equipment clean and always screw the lids back on bottles of solvent as they are a serious health hazard.

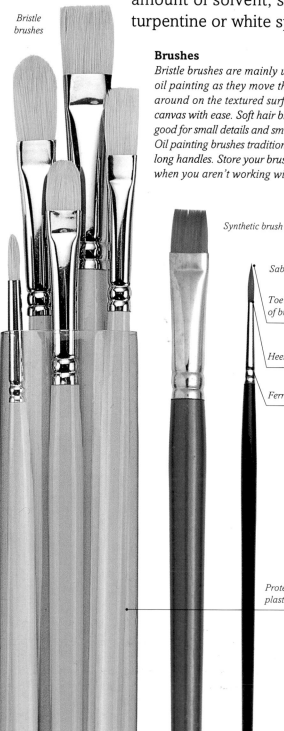

Bristle brushes

Brushes
Bristle brushes are mainly used for oil painting as they move the paint around on the textured surface of a canvas with ease. Soft hair brushes are good for small details and smooth effects. Oil painting brushes traditionally have long handles. Store your brushes safely when you aren't working with them.

Synthetic brush

Sable brush

Toe (tip) of brush

Heel of brush

Ferrule

Palette knife

Protective plastic case

Painting surfaces
Linen canvas

Primed canvas board

Wooden panel

You can paint on almost any surface, including stone, glass, and metal. The materials most commonly used are canvases and wooden panels such as plywood, hardboard, and fibreboard. Commercially produced oil paper is good for trying out ideas and techniques.

Palette and painting knives
Palette knives are indispensable for moving paint around on a palette and cleaning it off. Painting knives, on the other hand, are used for applying paint and have a differently shaped blade and handle.

Painting knives

Dippers
These containers store small amounts of solvent and painting medium on a palette.

MAHL STICK

If you need a steady hand to work on a particular area, use a mahl stick. A mahl stick is a piece of light bamboo, about 1.25m (4ft) long, with a ball-shaped end covered in soft chamois leather. You can make your own mahl stick if you prefer.

Modern palettes

Use a palette to mix your colors. You can make your own palette from plywood by sanding it down and sealing it with linseed oil. Alternatively, you can use a glass slab over a piece of paper, or a disposable paper palette.

Disposable paper palettes

EASELS

There are a variety of easels available from artists' suppliers, from the simple sketching easel that folds right up for easy carrying on location, to the heavy studio easels that can hold large paintings comfortably. Some artists like to work on paintings suspended on nails on a studio wall, or propped up on a table, but it makes sense to have a good adjustable easel for your work.

Vertical studio easel

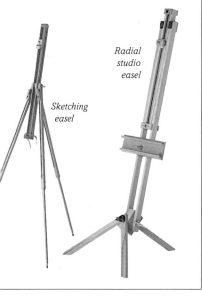

Radial studio easel

Sketching easel

Mahogany palette

This kidney-shaped mahogany palette, with its characteristic dark red-brown color, was originally developed for artists who worked on a similarly colored painting surface. This meant colors on the palette could be seen as they would look on the painting.

HEALTH HAZARD

Solvents can damage your health – screw the lid on after use and keep your studio well ventilated.

Solvent

You need to use a certain amount of solvent to dilute your colors and clean your equipment. Use either white spirit or turpentine.

Drying oil

Linseed oil is the basic medium for binding colored pigments and drying them when painted. Use it to modify the consistency of paint.

Oil painting medium

This enhances the consistency and glossiness of oil paint. If you don't want to buy it, mix refined linseed oil, or stand oil, with turpentine.

Varnish

Varnishes are designed to protect a painting and give it a matt or a gloss finish. Dammar varnish and ketone varnish are recommended.

CHOOSING COLORS

MOST ARTISTS LEARN about color by discovering how it works in practice. Painting is a constant process of individual experimentation and discovery, and it is unlikely that any two artists would work with the same colors. It is, however, helpful to look at some of the basic theories of color in relation to oil painting.

Ideally, artists would need only the primary colors of red (magenta), yellow, and blue, plus white, to mix any color. In reality it can be difficult to find suitable pigments of the purity that allow, for instance, the same yellow to make a pure orange with red, and a pure green with blue. Use instead a limited palette of versatile colors.

Color wheel
This color wheel shows the three primaries – red, yellow, and blue – and the three secondary colors in between that are made by mixing two of the primaries. The wheel also shows two main methods of mixing oil color; the paint has been mixed opaquely on the outside wheel, and transparently on the inside wheel.

These colors have been painted very thinly, or transparently, over a white surface, which shows their true color, and not as they appear when squeezed out of a tube.

Opaque colors, with their rich, well-bodied appearance, conceal the surface on which they are painted. Transparent colors can be made to look opaque by adding white paint.

Adjacent colors
Adjacent colors have some similarity in hue (the actual color of an object or substance). Green contains blue in its mix, which gives these hues an automatic link. On a color wheel with a wider range of colors, adjacent colors are those that are positioned next to one another.

Complementary colors
Pairs of colors situated opposite each other on the color wheel give maximum contrast and enhance one another to appear brighter.

Warm and cool colors
Reds are usually thought of as warm, and blues cool. In fact, depending on their hue and context, colors can be warm or cool. Here one red (left) is cool and the other red warm. It is important to know this when mixing colors, as the cool red makes a better violet if mixed with blue.

Arranging your palette
When you choose a palette of colors, try to include both a warm and a cool color of each hue, or a versatile color such as Winsor Blue. There are no set rules for laying out your colors, but it makes sense to place adjacent colors next to one another and to keep white paint separate.

The top six colors are mainly primary colors, combining opaque and transparent paints, and placed in the order of the color spectrum.

The paints along the side include naturally opaque earth colors and more muted, low-key colors.

Keep white paint slightly separate as it will be used mainly for lightening other colors.

Transparent and opaque colors

It is important to understand the difference between opaque paint, which conceals the surface it is painted on, and transparent paint, which appears dark in a tube but transparent when painted thinly on a white surface. The transparent Permanent Rose shown here has been thinned gradually to show its true color, and then mixed with white to give opaque "tints." Black is then added to give a range of different "shades."

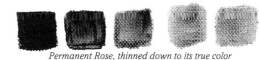
Permanent Rose, thinned down to its true color

If white paint is added, a range of opaque tints is produced

Touches of black mixed into the paint give dark shades

Recommended colors

The limited range of opaque [O] and transparent [T] colors (right) gives an extremely flexible palette, but add more colors if you wish. Recommended are all Cadmium and Mars colors, Light Red, Azo Red, Alizarin Crimson, Venetian Red, and Winsor Red, Arylamide or Azo Yellow, Manganese Blue, Cerulean Blue, Ultramarine Blue, Cobalt Blue, and Indanthrone Blue. Quinacridone (Violet), Dioxazine Violet, and Cobalt Violet are also good, as are Cobalt Green, Viridian, Terre Verte, Raw Sienna, Burnt Sienna, Flake White, Zinc White, Lamp Black, and Ivory Black.

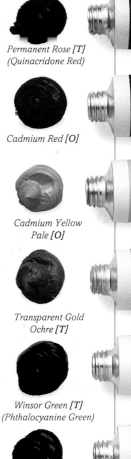

Permanent Rose [T]
(Quinacridone Red)

Cadmium Red [O]

Cadmium Yellow Pale [O]

Transparent Gold Ochre [T]

Winsor Green [T]
(Phthalocyanine Green)

Winsor Blue [T]
(Phthalocyanine Blue)

Titanium White [O]

Oxide of Chromium [O]

Yellow Ochre O]

Indian Red [O]

Burnt Umber [T]

Mixing primaries

It is easy to assume that a mixture of two colors will simply produce a single third color. In fact, the two colors together can produce many versions of the third color, in a wide range of tones. A useful exercise is to try painting a simple still life, such as the one below, using a range of tones in a secondary color that you have mixed from two primaries.

1 ▲ Before you paint these peppers, use a small scrap of posterboard and mix a range of different oranges from Permanent Rose and Cadmium Lemon (*below*). Then, with a clean medium-sized filbert bristle brush, paint the red pepper with shades of orange on a piece of oil paper.

Mix a range of orange tones before painting

PURE COLORS

Use two jars of turpentine to first clean off excess paint, and then rinse the brush. This will retain the purity and strength of each color you use.

2 ◀ Use lighter tints of orange or yellow for highlights, and darker shades of orange or red for areas in shadow. The lightness or darkness of each orange mix creates a "tone" that models and shapes the peppers so they appear three-dimensional.

Primary Peppers

These peppers look like real objects rather than flat images because a variety of different tints and shades create dimension and shape on each object. This range of clean orange tones has been achieved by carefully mixing different quantities of the primary colors red and yellow.

Pure red and yellow have been used, as well as the varied range of orange tones.

COLOR MIXING

WHEN YOU DECIDE to paint with a particular color, you have a choice of how you mix it and apply it to a painting surface. There are two principle ways of mixing colors. Firstly, you can mix together one color with another physically on a palette (*see below*), but you should always add small touches of the darker color to the lighter one so that you do not make more of the mixture than you need. A positive feature of oil paint is that the color you mix and apply wet has the same tone when it dries. Secondly, you can overlay one color onto another. A thin film of transparent red paint over a dry layer of yellow will give an orange color that looks quite different from a physically mixed orange. Another method of color mixing is to place small dots of pure color side by side. These appear to combine "optically," or visually, in the viewer's eye so that a third color is perceived.

Mixing clean colors

When you mix colors together, always mix them away from other paints on the palette to keep the original colors from becoming sullied. If you physically mix colors (right), use a clean palette knife or brush to transfer color each time. The brush must again be completely clean before you overlay colors (below). You can also mix colors in a "striated" brushstroke with separate colors on a brush (below right). To mix colors optically, gauge the right proportion of one color to another, or you will create something that looks gray. Allow one set of dots to dry before adding a new color.

1 ▲ Lay out the colors around the edge of your palette with a good gap between them so that they stay clean. Use a palette knife to transfer color away.

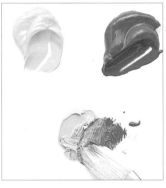

2 ▲ To physically mix green from these two colors, start with the yellow and add small dabs of the stronger blue paint to it as you mix.

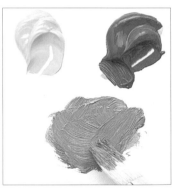

3 ▲ Continue to add touches of blue to the mix until you have the right shade of green. Make sure that both paints are thoroughly mixed together.

Dots of yellow and blue blend visually

A striated brushstroke contains two separate colors that give the impression of a third

Yellow painted stiffly over blue gives a broken green

A thin glaze of yellow over blue appears green

CARE OF PAINTS

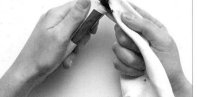

Paints are expensive, so it is worth taking care of your materials. Clean excess paint away with a tissue so that the lid screws on firmly. This also protects the strength and purity of a color, which can easily be ruined if the tube is neglected.

THE SIMPLE COLOR MIXING exercise on this page concentrates on mixing the actual color of objects in a still life. However, the colors are mixed in a variety of ways to achieve certain effects. Strokes of individual color are optically mixed or overlaid, while a touch of white added to the dark, transparent paint Winsor Blue gives a rich, deep opaque blue for the cloth.

1 ▶ Begin by sketching the outline of each object, and then fill in the shapes with color. Paint a layer of pure Winsor Blue on the pepper, and physically mix an orange color for the onion. The jug is opaque, so add some Titanium White to this mixture.

2 ▲ When the blue paint on the pepper has dried, overlay it with a separate layer of pure Cadmium Yellow, dabbed on with a small clean filbert brush. You should find that although touches of blue show through, the resulting effect will make the pepper appear green.

3 ◀ Use a small round brush to paint strokes of Cadmium Red and Cadmium Yellow on the onion. Keep the paint quite thick so that the colors look as strong and as pure as possible.

4 ▶ Paint a thin mix of Winsor Blue over the cloth, so that it deepens the color of the material and describes areas of shadow.

Still-Life Study

This study shows how many options there are to mixing colors, and the different effects they make. Separate strokes of strong color on the onion appear to merge into a vivid orange, while the jug has been painted with physically mixed colors that give a more subtle appearance. Although the pepper has been overlaid with paint, any touches of individual color still visible help to establish areas of light and shadow.

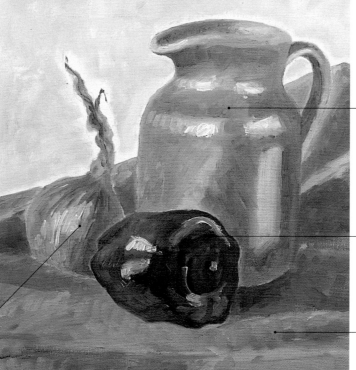

This jug has been painted with a physically mixed opaque color which gives it a strong, solid look.

A layer of yellow over thin blue paint gives this pepper a fresh appearance.

A thin film of transparent blue deepens the tone of the cloth.

Individual strokes of yellow and red appear to blend optically to give an orange color.

Sharon Finmark

LOW-KEY & HIGH-KEY COLOR

LOW-KEY PAINTINGS are usually defined by their subdued tones and color mixtures that tend toward neutral browns and grays. High-key paintings are exactly the opposite, with simple mixtures of pure, bright, saturated colors, often mixed with white. The strong distinction between high- and low-key painting needs to be made to enable us to focus our use of color in terms of our approach to subject matter. Many paintings contain elements of each, but certain subjects lend themselves well to the use of high-key or low-key color. These simple exercises show how easily the mood of a subject can change.

LOW-KEY PAINTINGS are often created with tertiary colors (a mixture of three or more colors), such as the Payne's Gray above. These can produce neutral, unsaturated hues. Some artists use a small range of neutral colors that are similar in mood and tone, but their paintings can vary enormously in atmosphere. This means that a work may be low in key and somber in mood, but it can either be a quiet, reflective study suffused with a subtle atmosphere, or painted in a dramatic way on a dark ground. Some subjects are by their nature low-key, such as moonlit scenes or dimly lit interiors, but almost any subject can be treated in a low-key manner.

1 ▲ Block in main areas of the composition using a large brush and mixes of opaque green, blue, and Payne's Gray, thinned with turpentine. Paint with loose brushstrokes to keep the composition simple.

2 ▶ Paint over the first layers of color with thicker opaque paint that has been mixed with a little oil painting medium. Use a medium-sized flat brush to capture the shape of the fish most effectively.

3 ◀ When the tone and depth of the composition is complete, add finer details and opaque highlights with a small round brush. Keep the highlights soft and subtle and without harsh lines.

Gutted Mackerel
This painting is composed of subdued, almost neutral colors that create a soft light and a gentle atmosphere.

A limited palette of colors keeps the work more powerful and controlled.

Opaque highlights help to create a subtle movement through the painting.

Elaine Halden

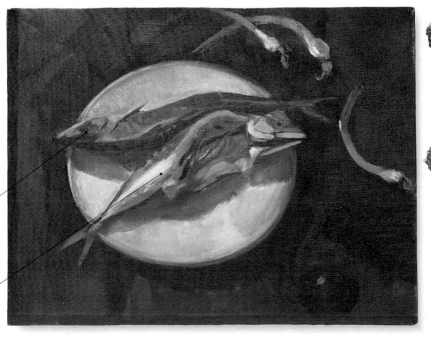

Payne's Gray

Cobalt Blue

Cerulean Blue

Cadmium Red

Burnt Umber

Yellow Ochre

Cadmium Yellow

Bright, saturated colors such as Cerulean Blue, left, produce high-key works that are light and optimistic in tone, but which can also be richly textured. High-key scenes are usually painted on white or near-white grounds that illuminate thinly applied colors to achieve high-key effects. Transparent high-key paints can be used opaquely by adding a little white paint to bring the color out.

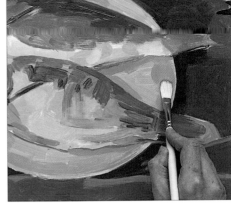

1 ▶ The white surface of this panel helps to keep the colors that are painted over it as bright and as luminous as possible. Paint the first coats of thin mid-toned color with a medium-sized filbert brush. Keep the colors as pure and as intense as possible.

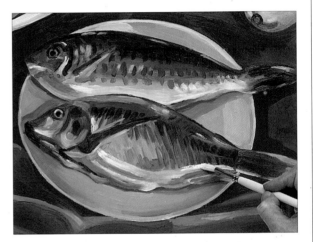

2 ▲ Use a smaller brush and a mix of Manganese Blue, Cerulean Blue, and Viridian, together with a touch of Titanium White, to strengthen the bright but cool color of the plate.

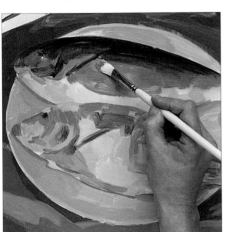

3 ◀ Paint bright markings on top of the initial thin layers of color to give the fish better definition. The first layers of individual color should have created a sufficient sense of shape and tone on each fish.

4 ▶ As the composition is built up, less white paint is mixed into each color so that the last layers look transparent and strong. Add final highlights of thick, stiff white paint with a medium-sized or small brush.

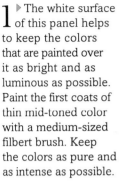

Parrot Fish
This work has bright, saturated colors, mixed mainly from primaries and secondaries, so that they retain their purity and strength.

Strong saturated color produces a heightened, vibrant atmosphere.

Complementary colors enhance each other to make the painting appear even more luminous and strong.

Jane Gifford

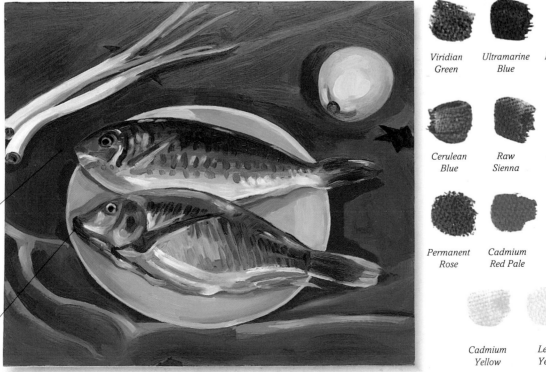

Viridian Green *Ultramarine Blue* *Manganese Blue*

Cerulean Blue *Raw Sienna* *Magenta*

Permanent Rose *Cadmium Red Pale* *Yellow Ochre*

Cadmium Yellow *Lemon Yellow*

GALLERY OF COLOR

IF YOU TURN THE COLOR CONTROL switch on your television set, you can make an image change dramatically from black and white, through a range of color effects, to brilliant, saturated color. When you paint, you are faced with a similar range of choices and dramatic effects. Your decisions about color should be affected by the nature of your subject and by the way you see it and want to describe it. Color can convey a mood or create an area of special focus. By placing one color next to another, or choosing one particular color rather than another, you can change the visual and emotional impact of a painting. Use color to say what you want, as well as what you actually see.

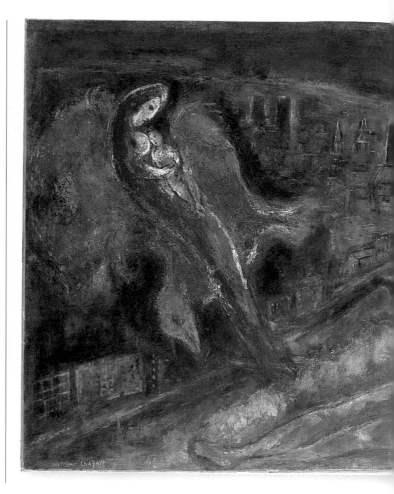

Frederick Gore, RA,
Bonnieux at Cherry Time, **1989** *26 x 20 in (66 x 52 cm)*
Gore has used what seem like unnaturally bright primary and secondary colors for this study. But he has captured the presence and feel of this French village far more accurately than if he had matched the colors carefully. Bright high-key color has been used to generate a feeling of warmth and spontaneity, which gives the work a strong impact.

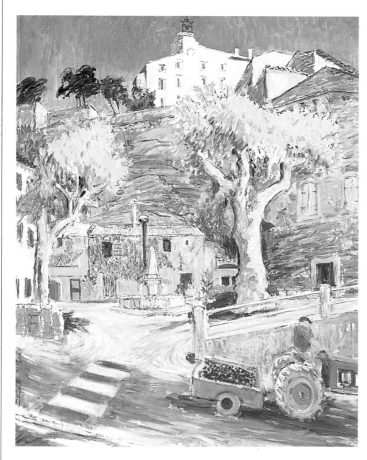

This detail shows how saturated yellows complement cooler lilacs and purples to heighten an effect of brilliant sunshine on the scene.

Lively, loose brushwork adds sparkle to the composition and gives the painting a more immediate quality.

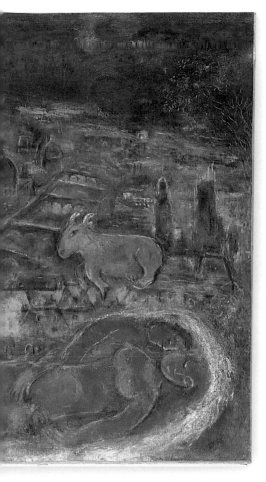

Marc Chagall,
Bridges over the Seine,
1954 44 x 91 in (110 x 230 cm)
Chagall's painting demonstrates how color establishes a particular mood or atmosphere. Above the cool dark city hovers a magenta and purple bird that seems to provide a haven for the woman and her child. The orange-red of these figures supported within the bird's wings generates a warm focal point for the work. Below, in the cool, calm blue of the foreground, a couple sleeps beneath this bright vision. The green goat, adjacent to the blue and complementing the magenta, provides a color link between all the components of the composition, and the harmony of strong colors is intensified by the dark background.

The color harmony in this detail is created by using colors that are adjacent to one another on the color wheel.

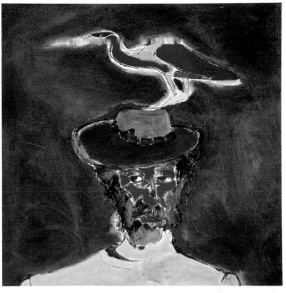

Philip Sutton, RA,
*P.S. as Don Quixote, c.*1989 *27 x 27 in (70 x 70 cm)*
Sutton has retained a clarity and purity of color in this work by having made clear decisions before painting about where particular colors will go. The lack of overpainting also keeps the colors clean. The painting relies on flat shapes rather than three-dimensional forms to keep the image strong: the bold blue shape defining the hair and beard encloses the complementary orange-reds of the face. This intensifies the color in the face and separates it from the background color, making it a focal point. It also contrasts with the bird in red and yellow, perched delicately on the man's hat.

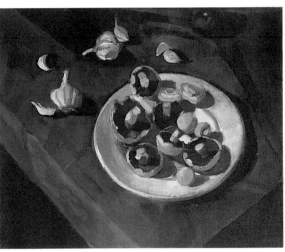

Elaine Halden, *Mushrooms* *18 x 20½ in (46 x 53 cm)*
This low-key study is painted with a subdued palette, yet it retains a fresh appearance. The vegetables are painted sparingly, while a hint of pink in the garlic and ochre in the mushrooms add subtlety to the color effect. The white circle of the plate gives the work a slightly formal quality.

Bernadette Kerr, *Scalinata* *33½ x 37¾ in (85 x 96 cm)*
The soft, almost abstract, forms in this painting are created with a limited range of warm ochres and terra-cottas and cool, muted blue-greens. Colors are unsaturated and used opaquely, and in some areas they have been mixed with white to produce a range of pale, low-key tints.

23

BRUSHES

This special cleaner suspends brushes in turpentine

THE BRUSHES YOU USE soon become a matter of personal choice, and when you have been painting for some time, you will begin to recognize exactly which brush you need to use for a particular area of your painting. Bristle brushes are used for large-scale work, impasto work, and more vigorous techniques. They are excellent for laying in large areas of flat or blended color. Sable or synthetic soft hair brushes should be used for more precise work with oil paint mixed to a creamy consistency. As you use your brushes you will find that they often become worn in a way that suits your style. Once they lose their spring and paint-carrying capacity, they may become suitable for other techniques, such as vigorous dry brush techniques (*see* pp.26-27).

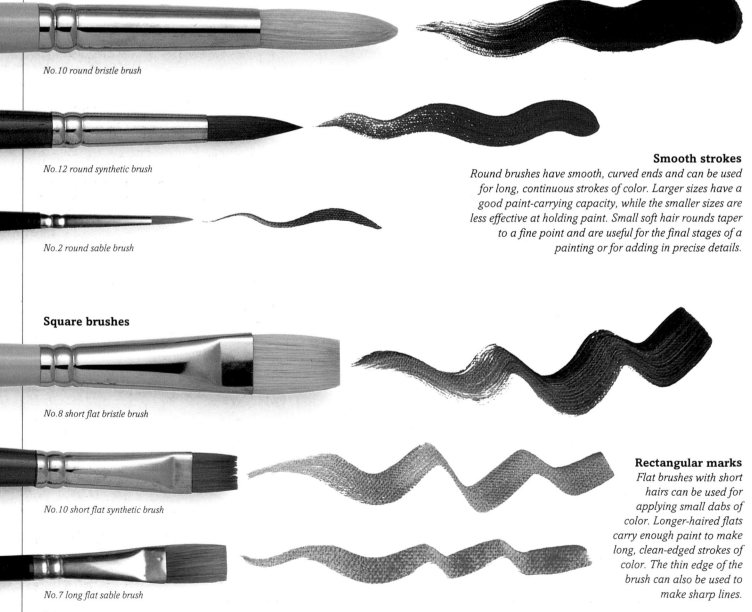

Round brushes

No.10 round bristle brush

No.12 round synthetic brush

No.2 round sable brush

Smooth strokes
Round brushes have smooth, curved ends and can be used for long, continuous strokes of color. Larger sizes have a good paint-carrying capacity, while the smaller sizes are less effective at holding paint. Small soft hair rounds taper to a fine point and are useful for the final stages of a painting or for adding in precise details.

Square brushes

No.8 short flat bristle brush

No.10 short flat synthetic brush

No.7 long flat sable brush

Rectangular marks
Flat brushes with short hairs can be used for applying small dabs of color. Longer-haired flats carry enough paint to make long, clean-edged strokes of color. The thin edge of the brush can also be used to make sharp lines.

Filbert brushes

No.10 long filbert bristle brush

No.6 long filbert bristle brush

Versatile brushwork

Filberts are made as round brushes with the ferrule, then flattened so that although the hairs are flat, they retain their rounded points. They combine some of the best features of flats and rounds, making rounded dabs of paint and strong lines of color.

No.5 short filbert synthetic brush

Specialized brushes

Bristle fan blender

Modifying the paint

A fan blender, or duster, is used for more particular techniques and to modify paint that has already been applied to a surface. The brush is used dry to soften edges or eliminate visible brushstrokes to give a very smooth appearance. It can also be used for delicate brushstrokes, such as adding highlights to hair.

BRUSH CARE

It is important to wash your brushes at the end of a painting session or they can be damaged permanently. If you leave them standing in a jar of turpentine, the pressure will distort the hair. Never use hot water to clean the brushes, as it may expand the metal ferrule and cause the hairs to fall out.

1 *Remove excess paint from the brush by cleaning it carefully with a cloth or a piece of paper towel that has been dipped in turpentine.*

2 *Dip the brush into a jar of turpentine and clean it thoroughly, pressing the tip of the brush against the base if paint still needs to be dislodged from the hairs or the ferrule.*

3 *Wipe the brush again on a clean part of the cloth to remove the last of the excess paint.*

4 *Use dishwashing liquid or soap to work up a lather with the brush in the palm of your hand.*

5 *Rinse the brush under a running tap of cold or warm water, making sure you remove all the dishwashing liquid completely and there is no trace of the pigment. Shake off the water and reshape the tip of the brush with your fingers. Store the brush upright in a suitable jar.*

BLENDING & DRY BRUSH

O IL PAINT IS ONE of the most adaptable painting mediums, and you can create many effects with it. There are several techniques for manipulating paint on a surface with a brush; blending, dry brush and scumbling, glazing, and impasto. Blending creates a smooth transition between colors, while dry brush and scumbling break up the colors to give texture.

Smooth objects
The hard, polished appearance and smoothly-rounded surface of this cup are accentuated by careful blending.

Blending

One feature that distinguishes oil paint from other painting media is its ability to be blended. Separate tones and colors can be painted onto a surface adjacent to one another and then blended by stroking a clean brush down the join between them. Blending may involve slightly softening the sharp outline of an object against a background, or working on a whole painting so that it takes on a rounded, seemingly three-dimensional effect. Use soft hair brushes for small-scale work and bristle brushes for large areas.

Use a clean, dry brush to blend separate colors. Make each gentle brushstroke in the same direction.

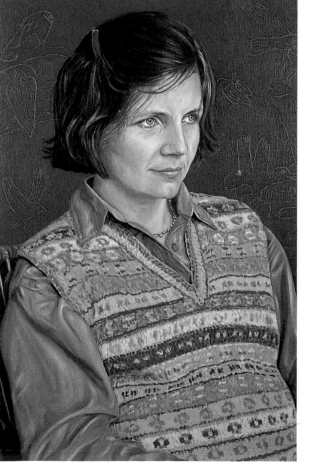

Realistic effects
This painting shows how oil color can be blended after it has been applied to a surface. The features of this woman's face have been modeled to give a subtle effect, shown by the smooth tonal change between the highlight on her left cheek through to her hairline and the smooth gradation of tone in her shirt sleeve. Tiny areas, such as the iris in the eye, also rely on smooth transitions between separate areas of color.

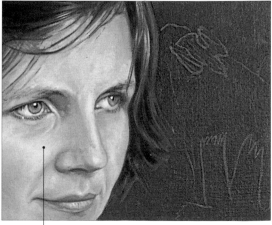

Both large and small areas of color in this painting have been blended smoothly together to create a soft, realistic sensation.

Dry brush and scumbling

Dry brush involves just a small amount of "dry" paint that is scrubbed thinly onto a surface with a bristle brush. One way of achieving this dry quality is to load a brush with color and wipe it on a rag before painting. Dry brush creates a broken color effect in which indentations or dips in the texture of a surface remain free of color while the raised areas pick it up. This gives a "halftone" effect, mingling a light tint (the white of the surface) with a darker shade (the color of the paint). Scumbling is the technique of painting over a dry layer of color using a dry brush effect, so that the color below shows through intermittently.

Scumbling is most effective when light color is laid over dark paint with a bristle brush.

Creating texture
The furry body of this teddy bear is suggested by scumbling a semi-opaque cream color over a deep shade of ochre paint.

Texture in a landscape

Dry brush or scumbling can give a painting a lively appearance, accentuating the impact of colors and textures. In this work, simple mixtures of colors in different tones have been used to define the broad shapes of a landscape. These mixtures have been dry-brushed into the weave of the canvas so that the image seems almost to be imprinted onto the surface. The matte color effects in clear, slightly shaded tones heighten the simple painting style. There is a lack of extraneous detail that, together with the absence of human figures, helps to maintain the textural quality and dreamlike atmosphere of this scene.

A thin mix of blue paint over the large area of sky picks up the rough texture of this colored canvas to produce a halftone effect.

The dry brush effects in this painting create an interesting visual sensation. The canvas and the broken paint combine to produce a series of halftones that echo the rough, barren look of the landscape.

GLAZING & IMPASTO

GLAZING IS A USEFUL WAY of enriching or deepening the tone of a color. A glaze is a thin layer of transparent oil color that is applied over an existing area of dry paint. The color is generally mixed first with an oil painting medium, which helps to adapt its consistency and increase its transparency. A glaze can also serve as a form of color mixing (*see* p.18),

A glaze enriches another color

so that a thin red glaze over a layer of dried yellow paint produces an orange color quite different in appearance from a physically mixed orange. Impasto, on the other hand, is a technique of applying a color very thickly so that a surface retains the character and shape of each brushstroke. Oil paint has a good viscous quality suitable for impasto, so it is usually applied straight from the tube with a painting knife or a bristle brush. Impasto produces a fresh, vigorously textured look.

Glazing

Glazing can be used for a number of color effects, as its transparent quality allows the layer of paint underneath it to remain visible. Several successive layers of rich transparent glazes can achieve a wonderfully deep, luminous effect in a painting. A glaze also brings a particular unity and harmony to a work with its uniform covering. The paint should be mixed with an oil painting medium (a mixture of stand oil and white spirit or turpentine) until it forms a puree like consistency, and then applied to the surface of a painting with a soft hair or bristle brush. Once the glaze has been applied, it can be smoothed into an even layer over the surface using a clean dry round brush. For large areas, a shaving brush is useful (*see* p.58). Before glazing, always make sure the existing paint layer is dry.

The glaze is painted thinly so that the color beneath can show through.

Deepening a color
The tones on this garlic are given depth, and the image greater substance, using transparent glazes.

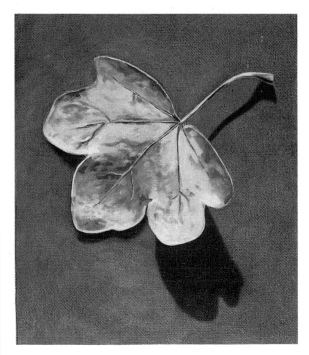

Producing harmony
This leaf study has first been painted in a range of tones of one color, or "monochromatically," using Burnt Umber mixed with Titanium White for an opaque effect. When this was dry, a glaze of Winsor Green has been applied over the surface of the leaf, with Cadmium Lemon for the highlights.

Touches of dark transparent Winsor Green are applied to the shadowy areas of the leaf.

Impasto

Oil paint can retain the crisp shape of a brushstroke, so it is well suited to the impasto technique. If you mix two colors together loosely and apply them with a brush, you can create a rich striated color effect with a highly textured quality. Impasto can also be useful if you need to work quickly or on a large scale so that you can cover a surface with thick, expressive brushstrokes. Impasto is a technique that relies very much upon making every brushstroke achieve exactly the right feel and sense of immediacy, so many artists who work in this way often scrape off an area that doesn't work and make the impasted brushstroke again.

Impasted brushstrokes heighten the rich, buttery quality of oil paint.

Retaining the shape of a brushstroke

An impasto technique can echo the appearance of the image being painted. Here the rough texture of a shell is reflected in these chunky brushstrokes. Applied wet-in-wet, the thick strokes of paint intermingle slightly so that streaks of color accentuate the textural effect of each brushstroke.

Thick paint can pick up light shining on it so that it seems to sparkle.

Thickly applied oil paint retains the marks or ridges left by a brush.

Loosely painted impasted brushstrokes break up the surface of a painting to create expression and vitality.

Lively brushstrokes

Painted largely with primary hues mixed with white, this image is built up with small touches of impasted high-key color. No color has been mixed with more than one other hue. Secondary blue-greens and oranges also predominate, vying with the yellows and reds. Touches of pure white have been added last for the highlights. Placed side by side, these separate brushstrokes create a lively patchwork of vibrant color.

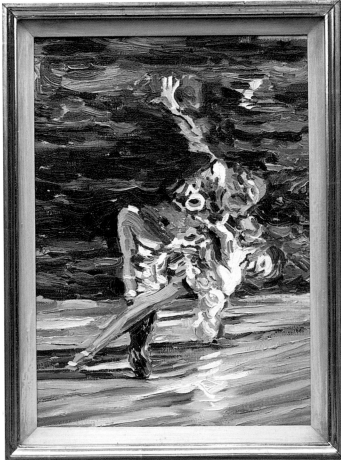

Rich impasted colors and brushstrokes dancing in all directions are held in check within the "arrow head" composition of the two figures.

BRUSHWORK EFFECTS

Look for interesting textures and surfaces in familiar scenes

PICKING THE RIGHT BRUSH is part of the skill of effective brushwork, and this choice takes practice. Soft hair brushes are most suitable for smooth effects and painting intricate work on a small scale. Hog hair or bristle brushes produce more "visible" brushstrokes, manipulating the oil paint into strong, vigorous shapes. Impasted strokes of thick color made with a hog hair brush can also exploit the rich texture of oil paint and give life to a work. When you paint, the amount of expression that you give to each brushstroke will determine the character and vitality of the work. Try to keep the images big and bold, working economically with large, loose brushstrokes. Remember that if you practice blending, you need to actually disguise individual brushstrokes and fuse the joins between colors and tones in order to create fully modeled images.

1 ◀ Often the most familiar scene or subject matter can reveal interesting textures and surfaces. This café has both rough and smooth surfaces and a strong light that throws some areas into dusky shadows. Sketch the composition in with a large brush, and then block in areas with color and establish patterns using a small or a medium-sized bristle brush and paint thinned with turpentine.

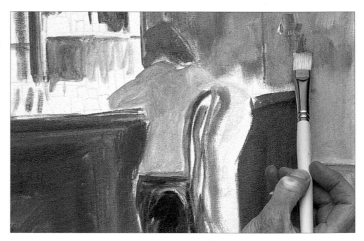

2 ◀ The first layers of thin paint should dry quite quickly. Drag a medium-sized bristle brush, loaded with color, over the dry surface to give a scumbled effect. The broken color should give the surface greater texture and a deeper tone.

WIPING OFF

The great advantage of oil paint is that it takes a long time to dry, so if you need to get rid of an unwanted brushstroke or color, use a piece of clean cloth to wipe off the mark carefully. Use one end of the cloth dipped in turpentine if you want to wipe the surface completely clean.

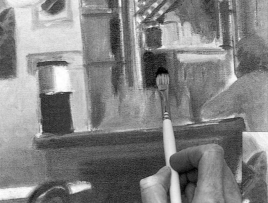

3 ▶ Overlay areas in shadow with darker tones. If you need to soften outlines or colors to give smooth gradations in tone or hue, wipe a clean finger over the paint so that the colors mingle gently.

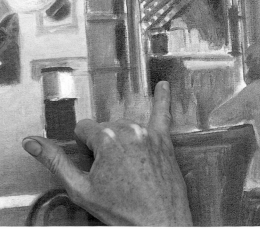

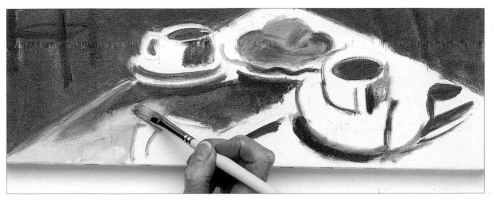

4 ◀ The marble top of this table has a cool, polished appearance, so paint a layer of violet over areas in shadow and then complement the violet with yellow highlights. Once these underlayers are dry, apply a cool mixture of Titanium White with a touch of Cerulean Blue over the table top. Use a small, clean sable brush to blend the paint to an even finish so that it looks like smooth marble. The underlayers of violet and yellow should show through faintly to suggest areas of light and shade.

5 ▶ Paint a thin transparent glaze of Alizarin Crimson over the floor area with a large synthetic wash brush to deepen the tone of the first hue. Mix the color with a little oil painting medium first if you need to make it more malleable.

6 ▶ Paint thick impasted highlights on any bright objects with a small, round bristle brush. Keep the paint as thick and as rich as possible so that the brushstrokes look bold and eye-catching.

7 ▲ Add definition to smooth objects by using a clean, flat synthetic brush to blend the paint evenly and to create strong outlines. Paint the brushstrokes in the same direction so that the join between strokes remains invisible.

The Café Scene
Different brushstrokes give a rich variety of textures in this study. The smooth marble table catches the eye, leading it to the center of the scene. A transparent glaze on the floor creates a subtle, luminous quality, while impasted highlights stand out in relief. Scumbled walls at the back of the café create a hazy, distant feel.

A dry brush technique on these wooden chairs increases their grainy appearance.

Teacups have been blended to look like smooth china.

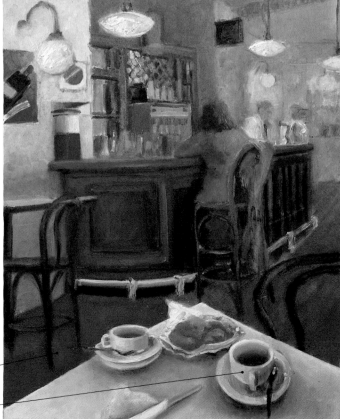

Sharon Finmark

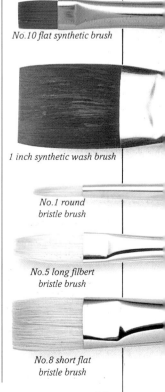

Materials

No.10 flat synthetic brush

1 inch synthetic wash brush

*No.1 round
bristle brush*

*No.5 long filbert
bristle brush*

*No.8 short flat
bristle brush*

31

GALLERY OF BRUSHWORK

THESE PAINTINGS GIVE a good indication of the range of brushwork effects that can be achieved with oil paint, from the smoothly blended "invisible" brushwork of Meredith Frampton to the boldly impasted strokes of Emil Nolde and the beautifully loose, expressive work of Manet. An artist's brushwork is much like handwriting – it reveals the intention and perhaps the personality of its author. Paint can be dabbed tentatively onto the canvas or stirred thickly and vigorously. A brushstroke can be fluent and deft, or clumsy and heavy. It can give movement and life to an area of the canvas, or hold an image or scene with controlled precision. The particular quality of brushwork also depends on the specific brush used.

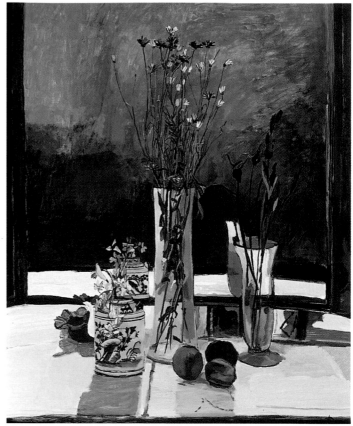

Ben Levene, RA, *Mixed Dried Flowers,* 1992 *51 x 43¾ in (130 x 111cm)*
This work subsumes a variety of different brushstrokes. Loose, scumbled brushmarks on the mirror convey a sense of distance, while objects in the foreground are painted in with careful, yet decisive small brushstrokes.

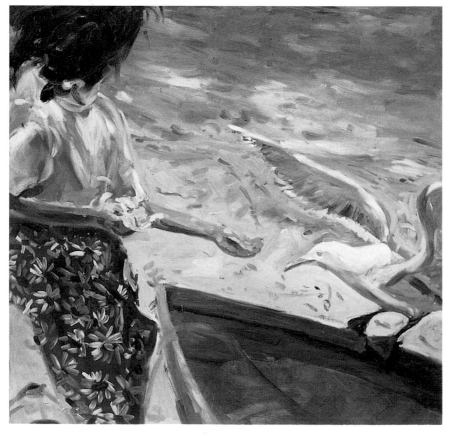

Roger Oakes,
First of Summer
48 x 48 in (122 x 122 cm)
In this lively composition, the brushwork is loose and strong, following first the diagonal line of the sea, then becoming varied and more agitated around the bird's wings. Details are also freely painted.

Daisy designs on the girl's skirt, shown clearly in this detail, are built up of particularly relaxed brushstrokes.

White highlights are sketched on loosely with opaque white paint so that they create a simple yet effective pattern.

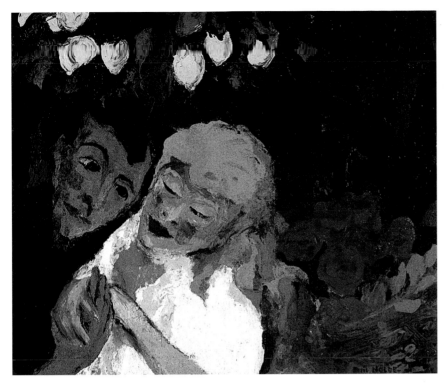

Emil Nolde, *In the Lemon Garden*, 1933 *28¾ x 35½ in (73 x 88 cm)*
This painting carries off its mood of unabashed and tender romanticism because Nolde has painted it with such direct assurance and expression. Clear shapes of saturated color have been applied with thick, heavy brushstrokes so that solid blocks of bright yellow, red, and orange glow against the loosely painted dark greens and purples in the background. The cool blue of the woman's face and arms have also been broken up by scumbling thicker, drier paint across the canvas. Such evocative brushstrokes give a feeling of joyfulness amid the sultry perfumes of this secret arbor.

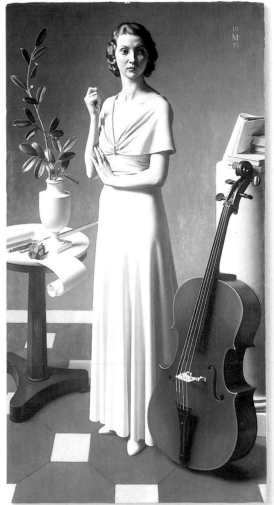

The delicate blending between individual brushstrokes gives a rounded poise to each element of the work and creates a mood of quiet stillness.

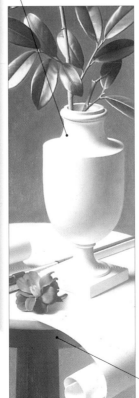

Edouard Manet, *Au Bal*, c.1870-80 *22 x 14 in (56 x 36 cm)*
This loosely worked study clearly shows the marks of each brushstroke as Manet worked rapidly to capture a profile. The sense of immediacy arises from a vivacity and economy in the brushwork, with a busy cluster of horizontal strokes describing the dress and more controlled strokes for the hair.

Meredith Frampton, *Portrait of a Young Woman*, 1935 *42½ x 9¾ in (108 x 25 cm)*
This work is a good example of tones and colors that have been blended so perfectly that there is almost no evidence of visible brushwork. This is illusionistic painting at its most refined, and it gives the figure and the objects the rather cool quality of smooth marble.

This detail demonstrates how the edge of an area of oil paint has been smoothed where it abuts with another color so that there is no harsh edge linking the two.

33

CHOOSING A SUPPORT

A SUPPORT IS THE SURFACE that you paint on, and the type of material you choose is ultimately a personal choice. You can paint either on a rigid support, such as a board or a panel, or on a flexible support such as canvas, but within that choice there are a range of different surface textures to pick from that affect the way the paint behaves. Canvases and boards each have their own characteristic feel, and there is a big difference between the two. A hard, rigid support enables you to prepare a roughly textured surface for painting that would be quite impractical on a stretched canvas, but the flexibility and texture of canvas makes it a far more responsive surface on which to paint.

Canvas boards
These combine the rigidity of board and the texture of canvas. Although available from artists' suppliers, they are easily made by gluing linen to a piece of hardboard and then priming the entire surface.

Blockboard

Plywood

Chipboard

Hardboard

Medium density fiberboard

Types of panel and canvas

Rigid supports provide a sounder and more permanent basis for painting. The advantage of using a board is that you can alter its surface texture by "priming" it roughly or smoothly (*see* p.37). Wooden panels covered with linen are particularly durable. The most common materials for panels nowadays are fabricated boards such as plywood, hardboard, and fiberboard, rather than the traditional mahogany, poplar, and oak. Hardboard is a good choice, particularly for smaller panels. A recent development is honeycomb aluminum, which provides a strong support.

A traditional flexible support is linen canvas, and the flax fibers from which linen is woven are long and strong. Cotton fibers are not as strong, but some excellent cotton canvases are available in heavier weights. You should use at least a ten-ounce canvas cloth, and preferably a 12 ounce one. Weight is not so important when choosing a linen canvas. A new material, though not yet widely available, is the flexible, yet stable, polyester sailcloth.

Cotton duck 12oz

Ready-primed canvas

Coarse linen

Fine linen

Grained cotton

Cotton duck 15oz

Rough and smooth boards

A rough surface breaks up the smoothness of a brushstroke, giving it a pitted or textured appearance and producing a craggy, chunky version of an image (below). The board must be primed with loose brushstrokes to create this expressive effect, perhaps with sand in the primer to give a gravelly texture (see p.54). Use the back of a piece of hardboard if you prefer a regular texture. Bristle brushes also increase the degree of texture. On a smoothly primed board, soft hair brushes give more control for modeling and blending forms and details. Alternatively, make sweeping brushstrokes that are unimpeded by any texture on the support so that you clearly see each brushstroke (right).

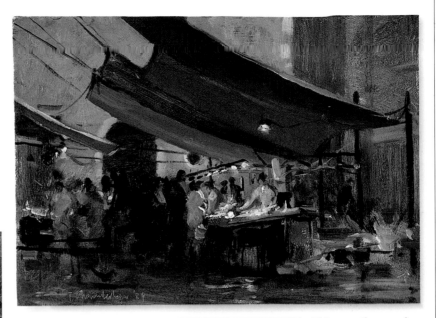

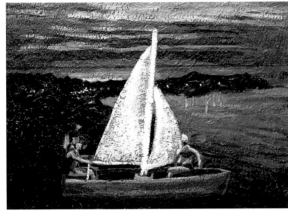

The rough texture of these brushstrokes and the rugged appearance of the work is provided entirely by the nature of the ground.

This smooth ground shows up the texture of both thick and thin brushstrokes.

The energy of these brushstrokes retains a sense of freshness and immediacy.

Rough and smooth canvases

The texture of canvas can vary enormously, from the smooth, hard surface of wet-spun linen made from fine flax, to the rough texture of dry-spun coarse linen made from tow flax. Generally the finer the woven canvas, the smoother it will feel and the more refined your painting will be. A smooth canvas enables you to work with great precision and detail with soft hair brushes, while a coarse canvas encourages a more vigorous approach with bristle brushes. Try various grades and types of surface to see what kind of canvas will best suit your style of painting.

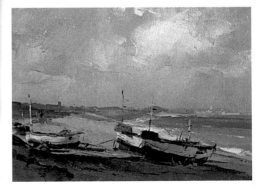

The dry brush technique on this coarse, open-weave canvas makes the work seem part of the texture of the support. The harshness of the material echoes the knotty, rough quality of fishing nets, creating a continuity from the image of fishing boats to the surface quality of the painting.

The smooth quality of this fine-weave canvas allows each small image to be painted clearly and delicately. Paint can be applied easily to this type of canvas, and the flexibility of the cloth encourages a light, refined painting style.

PREPARING SUPPORTS & GROUNDS

CHOOSE A SUPPORT that suits your painting style. It can be rigid and stable, such as a wooden panel made of oak or poplar, or more commonly of hardboard or plywood; or it can be flexible, made of cotton, linen, or polyester canvas. The ground is what you put on the surface of the support in order to prepare it for painting. The surface is initially sized to seal it and prevent oil from the paint from being absorbed into the wood or canvas. A primer, either toned or white, can then be applied over the dried sizing.

Materials

Wooden stretcher pieces

Scissors

Staple gun

Wedges

Hammer

Linen canvas

Stretching a canvas

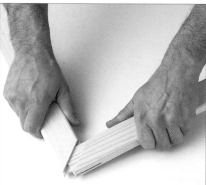

1 ◀ Start by slotting the four edges of the stretcher together. Tap a rubber hammer on each corner if the pieces become stuck.

2 ▶ Lay the stretcher over a large piece of canvas and then cut around it with scissors, leaving at least 3in (8cm) of canvas clear.

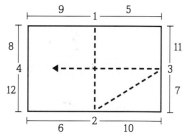

3 ▶ Stretch the linen canvas over the rigid wooden frame using thick staples and a staple gun. Put a staple in the frame wherever there is a number on the diagram (*right*). Work in number order. This ensures an even tension in the taut canvas. Fold the canvas over the frame firmly rather than pulling hard; if you stretch it too tight, it may begin to strain and distort.

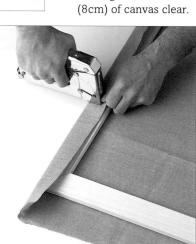

The canvas must be stapled in a specific order

4 ◀ Once the sides of the canvas have been attached securely to the frame, maintain an even tension at each corner of the support by stapling down the overlapping material. Neatly make two folds out of the canvas and then pull one fold over the other. Secure the folds to the frame with a staple.

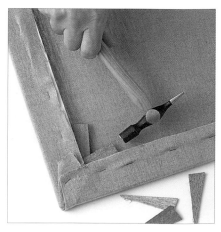

5 ▲ Finally, tap four wedges into each corner of the frame with the hammer. These wedges help to tighten the frame a little more, making it as rigid and as taut as possible.

Sizing and priming a canvas

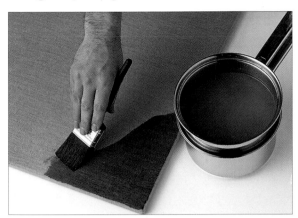

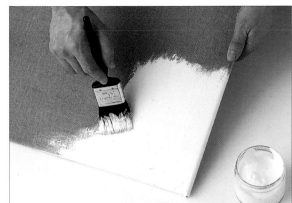

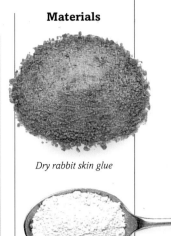

Dry rabbit skin glue

Gesso powder

1 ▲ To size a canvas, heat 1 quart (1 liter) of water in a double boiler (or a pot in a saucepan) with 1oz (30 grams) of dry rabbit skin glue. Paint the mix over the canvas with a general purpose 3in (8cm) brush.

2 ▲ When the sizing has dried completely, prime the canvas by adding gesso powder – plaster of paris – to the glue size until you get the consistency of thick cream. Then cover the canvas with the white primer.

Sizing and priming a panel

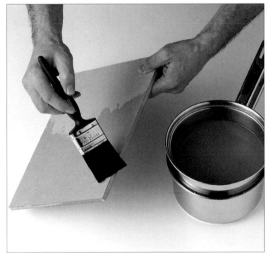

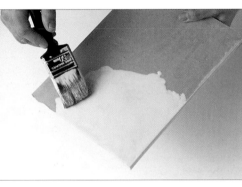

1 ◄ Panels are also sized, but add 2½oz (70 grams) of rabbit skin glue to the water.

2 ▲ When the size is dry, prime all the surfaces of the panel with gesso primer.

Double boiler

3 ◄ Once dry, sand the panel with very fine sandpaper to give it a smooth and even finish.

4 ▶ Finally, apply one more layer of glue size to the whole panel to seal the surfaces completely.

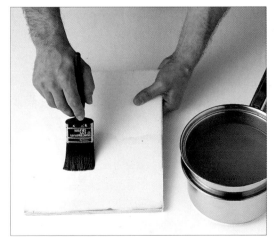

General purpose brush

Medium density fiberboard

Primed canvas

Roughly primed board

Smoothly primed board

Sandpaper

WAYS OF WORKING

MOST ARTISTS BEGIN TO DEVELOP their own techniques and individual style after a long period of experimentation and discovery. For beginners, it makes sense to experiment as much as possible with many different approaches to painting so that you can build up a technical repertoire and discover ways of working that suit your own personality.

The basic art of painting

If you begin by painting small, simple objects, preferably with some sort of personal meaning, you will be able to concentrate on how you paint without worrying about extraneous details, or the initial difficulties of drawing. If you look at the work of past and present painters whose style you admire, you will see that in most cases it is largely a question of what is actually left out in the process of painting that makes their work so successful (*see* Galleries *throughout*). Simple domestic objects or toys make good subjects when you start to paint. They generally have a nice simplicity, which makes them appropriate subjects for drawing and painting. Start by painting what you see as straightforwardly as possible, and then concentrate on different ways of approaching the same subject. You may find it easier to begin working on a small scale in a rather careful style, drawing the outlines of the subject and pre-mixing a small range of tones, and then carefully filling the outlines in, stage by stage, with a soft hair or small bristle brush.

This is a good way of discovering the feel of the medium and learning how to control your brushes. After all, the basic art of painting is very much about matching what you can see, imagine, or even recall with a particular mixture of color applied in a certain way.

Developing style and technique

Painting familiar subjects will help you build up the confidence to experiment with the objects you work with. Practice laying in the shadows on a flower with a range of tones, for instance, or blending separate colors with a dry brush to achieve the smooth, rounded finish of an egg. If you choose to paint a rough-textured object, such as a piece of driftwood or a small rock, try a different technical approach and represent the crags and facets that characterize these objects with a range of different tones and loose, chunky brushstrokes.

Complex arrangements

Once you have looked at individual objects
on their own, you may decide to paint a more
complex arrangement that includes a number
of objects. Here your approach to painting can
be just the same, except that you will have to
make decisions about how you organize your
composition. Try to establish a sense of balance
between the forms. This does not mean that
what you see must be staid and solid, but that
there should be a link or a thread running
through the arrangement that binds it together.

You should also decide what kind of visual impact you want the composition to make.
A composition that fills the frame will convey a sense of boldness and generosity – or you
can create a feeling of separateness or isolation by painting gaps between the objects. This
kind of experimentation with simple, accessible forms can be invaluable in experimenting
with styles and approaches, giving you the confidence you need before you decide to tackle
the more difficult subjects of portraits and landscapes.

Visual aids

It can be helpful to use photographs for visual reference when you work on a complicated
subject such as a landscape, as you have the benefit of a three-dimensional scene or object
already transcribed into a flat, two-dimensional image. Try to paint freely and not to copy
the image exactly as it appears, or the painting may become cramped and look awkward.
It is better to make a free transcription that leaves out all the unnecessary details and
allows you to practice looking, for example, for cooler colors and lighter tones toward
the horizon, which help to increase the sense of aerial perspective.

Working with confidence

When you come to work freely with any subject in any situation, the kinds
of simplifications that you have practiced previously are all still entirely
appropriate. When working from life, an artist needs to
make a mental synthesis of the subject being painted,
select the most interesting elements that will override
the mass of extraneous detail, and allow the
painting to develop as a succinct and
self-contained world in its
own right. In this way,
you will learn to discover
a painting style that is most
suited to you, and to adapt
techniques to create new
and unusual effects.

CREATING A COMPOSITION

COMPOSITION IS A TERM THAT DESCRIBES the organization of space in a picture – ordering shapes, forms, and colors in a way that is appropriate to the meaning of the image. When you are putting a composition together, look for balance and a sense of appropriateness, trusting your intuition. If you are working from life, look at the image through a viewfinder. Move it closer to and then farther away from the image until you see the composition you want. If you are working from a photograph, try cropping areas of the image with small strips of paper.

Viewfinder

Cut a window in a piece of posterboard and use it to look for the best composition.

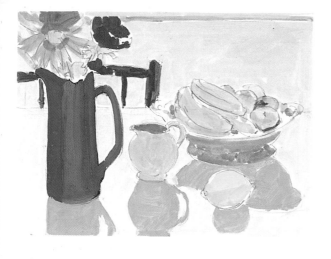

Looking for a composition

The most interesting composition is usually one that gives an image a fresh slant so that you perceive it in a new way. Arrange a still-life composition on a table top, and then sketch it from as many different angles as you can think of. Try to be adventurous, closing right in on the still-life or sketching just a few elements of the composition.

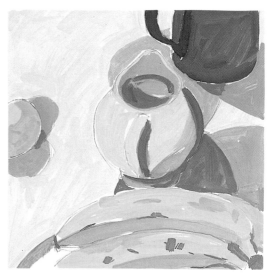

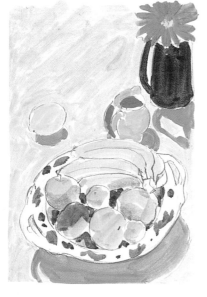

Visual impact

As you sketch, look for the way colored objects react with each other to create a subtle harmony or a vibrant contrast. You may want to rearrange objects to achieve a better visual impact.

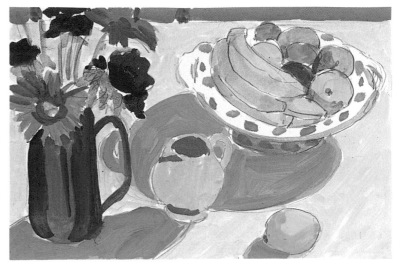

Transferring a sketch

Once you have selected the most interesting composition, the best way of transferring it to a canvas or a board is to use a grid system (see also below right). Place a grid over the original sketch and draw a similar grid on a larger scale on the support. Transfer details from each square on the sketch using charcoal (below), or drawing directly with a brush and a thin mix of paint (right). Pencil can be used very faintly, but it is generally not recommended as it can soil the color of the paint. Some artists like to fill the outlines of shapes with light cross-hatching to determine areas of tone.

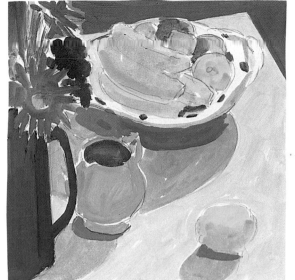

USING SLIDES

Slides can be used to transfer an image, whether it is a favorite scene or a slide of the sketch itself. Hang a panel or a canvas on a wall and shine the image onto it using a projector. You can determine very easily how large you want the image to be by moving the zoom lens on the projector. Then trace in the basic outlines of the composition with a piece of charcoal or a brush and a thin mix of paint. Polaroid pictures or photographs can also be useful for visual reference while you are painting, but you may like to crop the image first with small strips of paper to select a simplified or unusual composition.

If you draw directly with a brush, use a thin mix of paint in a light or neutral color so that it does not show through the painting.

Drawing grid

Draw a grid of squares onto a piece of tracing paper or acetate and then place it over the original sketch. This may seem like a laborious process for transferring an image, but it is a useful way to make sure the proportions of the composition remain intact.

Drawing grid

Doughy bread

Dusting off

If you draw with charcoal, use a large soft brush or a piece of doughy bread to dust the charcoal off and leave the residual image as a guide. Another option is to seal the charcoal with a fixative.

COMPOSITION

LOOKING AT A LANDSCAPE or an interior, it can be difficult to know quite where to establish the broad areas of a composition for painting. It can sometimes be helpful to think of the eye like a camera lens, zooming in on a scene to focus on just one element, or pulling back to encompass a wide viewpoint and include more visual information. You will also need to decide what the boundaries of your composition will be. An image can be placed partially within the frame, so that the picture seems to be part of a much larger scene, or placed centrally, so that every aspect of the scene is contained within the frame. Unusual angles and perspectives can create added interest.

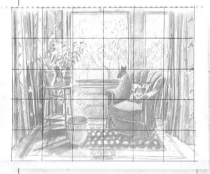

1 ▷ Select the most suitable composition and transfer the sketch onto the canvas with the aid of a drawing grid. This grid system should help you retain the correct proportions of the sketch as you draw the composition out on the canvas.

Make several sketches to discover the most interesting composition

2 ▷ Block in the main elements of the composition with areas of flat color, thinned with turpentine. As this interior scene has sharp distinctions of lights and darks, try to establish these areas as soon as possible so that they stay clearly defined.

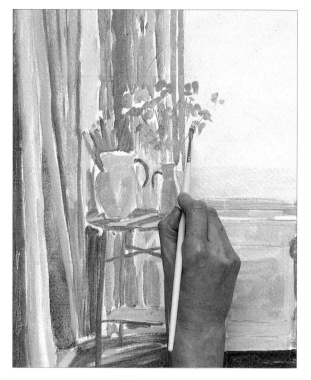

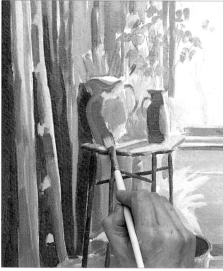

3 ▲ Build up the tones and shadows on each individual object to heighten the color and establish a sense of light. The thick stroke of dark color on this jug gives it more of a three-dimensional form.

4 ◁ Mix two separate colors to build up the lights and darks on this chair. One mix of Viridian, Cadmium Yellow, Raw Sienna, and Yellow Ochre, painted on with a medium-sized bristle brush, captures the light hitting the back of the chair. A touch of Ultramarine Blue with the Viridian gives dark shadows.

6 ◀ The carpet and curtains in this painting play an important part in establishing a strong sense of perspective; both carpet and curtains recede at a sharp angle, so patterns or markings at the edge of the carpet should be painted proportionally smaller. Paint such details with a fine sable or synthetic brush to keep the effects soft.

5 ▲ Once an area has been built up with thin paint, overlay it with more saturated mixes of bright color to give the effect of strong light. When you describe the intensity of such bright light, keep the contrast between colors as sharp and as clean as possible. Deepen dark areas to make this contrast more dramatic.

7 ◀ The landscape visible through the large windows should be painted in much paler colors to create a sense of distance and aerial perspective (*see right*). Dab touches of color lightly over the canvas with a medium-sized bristle brush. A dark glaze over the window frame helps it retain its rich color and contrast with the pale light beyond.

AERIAL PERSPECTIVE

Aerial perspective is a term that describes the effect of atmospheric conditions on our perception of the tone and color of distant objects. As objects recede towards the horizon they appear to become bluer and lighter in tone. Artists generally work from light tones at the back of the composition to the darker tones at the front.

Jude's Sitting Room
This painting really describes a frame within a frame. The perspective created by the curtains and carpet lead the eye up into the central area of the painting, which has every object at an angle to increase the degree of interest in the composition.

A good variation of tone and color describes objects well and keeps the composition lively.

Dark shadows contrast with strong areas of light and pale color through the windows.

Darker, stronger colors in the foreground push the bottom of the painting forward to catch the eye and improve the perspective of the painting.

Jane Gifford

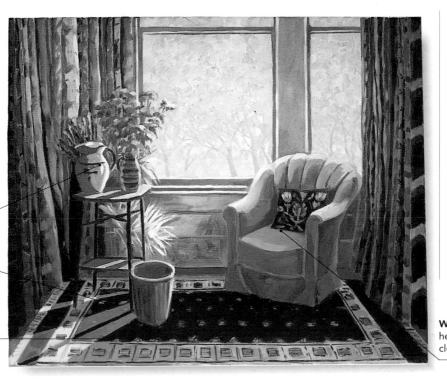

Materials

No.4 round sable brush

No.1 round bristle brush

No.8 round synthetic brush

No.4 long flat bristle brush

Well-balanced colors help to create a strong closed composition.

GALLERY OF COMPOSITION

COMPOSITION IS ALL ABOUT establishing an appropriate relationship between various elements of your painting, such as form, tone, and color, so that together they generate the meaning you want a painting to convey. When you establish the basic structure of a composition, ask yourself whether it communicates what you want to say about your subject, or whether changing the size, position, or structure of a particular feature will make your work clearer. In these paintings, each variation creates a different impact. A low viewpoint in one painting can cause isolated objects to appear dramatically bold and create a strong psychological effect, while a high viewpoint in another work allows individual elements to become part of a broader scheme that stretches away before the viewer in a leisurely, pleasing way.

Simon Ripley, *On the Edge* *17 x 14 in (43 x 36 cm)*
Ripley's unusual composition places a vase on the far end of a table as if it is spinning off the edge. Large areas of orange-red complement the small active cool blue of the vase in this strange and evocative work.

Oskar Kokoschka, *Broad View of the Thames*, 1926
35 x 51 in (89 x 130 cm)
Kokoschka's painting is an excellent example of the way an artist can manipulate space within a composition in order to show more of the panorama than is possible with a conventional linear perspective. Here Kokoschka has utilized a form of curvilinear perspective, pushing the painting into an all-embracing circular composition. The artist's high viewpoint also allows more of the river and ground to be included in his panoramic sweep.

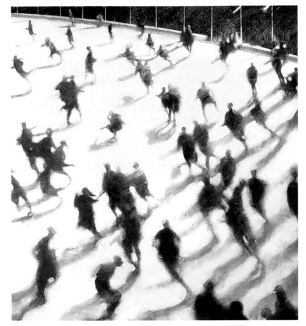

Bill Jacklin, RA, *The Rink III,*
1991 *78 x 72 in (198 x 183 cm)*
This image of moving ice skaters creates a very effective open composition, a term which implies a continuation beyond the bounds of the canvas. There is a wonderful sense of swaying movement in the painting, brought about by the angle of the figures in the middle ground and foreground and their long shadows that sweep down on a diagonal, impelling the eye down and around through the moving bodies. There is also a kind of icy breathiness about the color scheme of the work that perfectly recalls the physical atmosphere of the scene.

Carel Weight, RA, *The Frustrated Tiger,* **1992**
71¼ x 59½ in (181 x 151 cm)
The two pairs of figures in this unusual composition create a strange symmetry, with curious shapes and mysterious shadows linking all the elements together. The turbulent sunset and the distant childlike image of the tiger combine to create an extraordinary atmosphere.

Sir Robin Philipson, RA, *Poppies, c.1985*
30 x 40 in (76 x 102 cm)
This study of poppies is a fine example of a closed composition, in which everything is contained within the frame. The vase and flowers fill the space generously without going beyond it. The adjacent harmony of the powerfully warm hues intensifies this small, closed world.

PAINTING ON A WHITE GROUND

A WHITE GROUND PROVIDES a perfect surface for reflecting the purity of a color painted over it. A transparent color that looks dark in a tube appears as a brilliant saturated hue when it is painted thinly over a white surface. Semi-opaque and even opaque colors are also given a particular clarity on a white ground, especially since there is often a variation in thickness between individual brushstrokes. Generally, more painting is required on a white ground in order to cover the white surface, while a colored or toned ground provides a useful unifying matrix between the brushstrokes of different color.

Influencing the look of a color
These examples of Permanent Rose demonstrate how easily the appearance of a color changes. The top squares, painted first thickly and then thinly, retain their brilliance and purity on a white surface. A colored ground (above) subdues the luminosity of the transparent paint.

Make a sketch on white paper to plan the color scheme

SINCE WHITE REPRESENTS the brightest highlight a painter can create, most of the white ground in this exercise has been covered to achieve a more accurate representation of tones. As you paint over the white ground, bear in mind that the colors you paint will initially look much darker on the dazzling white surface than they will when you have finished the painting and covered up most of the white ground.

1 ◀ A white ground suits this subject matter perfectly, as it can illuminate the colors painted over it to give a sensation of strong summer light. Sketch the landscape with thinned paint and a small round bristle brush, and then block in main areas of color with a clean brush.

2 ◀ This work relies on strong color to make its impact, so use pure complementary colors to achieve the maximum effect. Pick out areas of the foreground with warm colors such as orange, yellow, and red, and then complement them with cooler colors such as blue, violet, and green in the distance. Cover as much of the white surface as possible with the thin mixes of color.

3 ◀ Use a cold, clean blue, such as Cerulean Blue, for the sky. To avoid painting a heavy, flat area of color, lighten some Ultramarine Blue with touches of white and use it to break up the large expanse of sky with a long filbert bristle brush. Keep this paint dry and thick so that you can create a scumbled effect over the first layer of paint. This should give the sky a richer texture and a deeper tone.

4 ▷ Once you have covered all the white ground, you may find that some areas of color still look quite weak, so refine and strengthen the look of objects with mixes of bright, saturated color. Use a versatile green, such as Winsor Green, to increase the range of tones and emphasize the particular shape of each tree. Use a small round bristle brush for any intricate details. If the particular area you are working on is still wet with paint, maintain a steady hand by using a mahl stick (*see* p.15).

5 ▲ Apply a pale mix of Cerulean Blue, lightened with white and painted in with a fine sable brush, to provide an effective contrast with the warm orange rooftops. The coolness of the mix also increases the sense of aerial perspective in the painting.

6 ◁ Add strokes of hot color, such as pure Cadmium Red, to enliven the foreground area and contrast with the banks of green trees beyond. Use a dry brush technique and plenty of saturated paint to give both texture and brilliance to the final look of the painting.

A dry brush technique breaks up large areas of color, but the touches of white ground that show through also increase the brilliance of this blue paint.

Materials

No.2 round sable brush

No.1 round bristle brush

No.5 long filbert bristle brush

Provence Landscape

A white ground allows saturated colors to show their freshness and brilliance in this painting. The hot summer atmosphere is heightened by several complementary colors that enhance one another to look even brighter. Energetic brushstrokes and interesting texture give the scene movement and vitality.

Warm colors painted in the foreground are complemented by cool background colors that create aerial perspective.

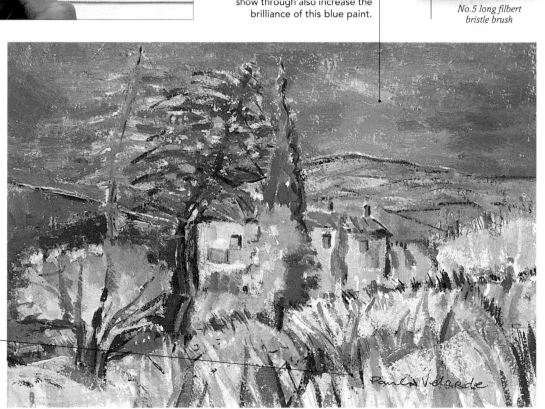

Paula Velarde

PAINTING ON A TONED GROUND

THE GREAT ADVANTAGE of working on a toned or colored ground is the economy it can bring to your painting technique. Paint darker tones in transparent colors, which allow the ground color to show through, and lighter tones in opaque colors, which obliterate it. The mid-tones are provided by the color of the ground itself, so that you soon have a work with a very finished appearance. It would take much longer to reach the same point working on a white ground. The Yellow Ochre mid-toned ground used in the exercise below provides a warm underlying tone for the work and acts as a unifying element in the painting.

PREPARING A TONED GROUND

There are two ways of coloring a ground – either by laying a thin transparent veil of color over the white priming (this is known as an imprimatura) – or by laying an opaque layer of color over the primer. Allow plenty of time for the color to dry before painting.

1 *A toned ground can be any color, but warm red ochres and browns can give more richness to a work. A thin transparent wash of imprimatura can be made by mixing Burnt Umber and Yellow Ochre and adding turpentine to reduce the paint mixture to a thin consistency. Apply the imprimatura freely and evenly over the support, in this case a panel, with a large bristle brush.*

2 *Let the solvent in the mixture evaporate for a few minutes, and then rub the surface with a cloth to take away the excess paint. This means that the white priming has a stain of transparent color rather than a coat of paint. The main advantage of using an imprimatura rather than a toned ground is that the film of color allows the white of the original priming to retain its reflective quality on the colors painted over it.*

The opaqueness of a colored ground ensures a complete uniformity of tone over the surface of the support. A colored ground can also be laid by mixing color in with the primer itself before it is applied.

Toning a primed canvas
This canvas support has already been primed with white primer, and a colored ground made of Burnt Umber, Yellow Ochre, and Titanium White is laid over the top with a large wash brush. A colored ground will take longer to dry than an imprimatura, so ensure that it is completely dry before you begin to paint. Most colored grounds will take a few days to dry completely.

1 ◁ Sketch in the composition with a medium-sized bristle brush and a thin mix of Burnt Umber. The ground has been prepared with a mix of Yellow Ochre, Gold Ochre, and Titanium White.

2 ▷ Break up and enliven areas of the colored ground using a medium-sized bristle brush and a slightly thicker mixture of Yellow Ochre with a touch of Titanium White and Cadmium Red.

3 ▲ Once you have blocked in all the shapes and dark areas of shadow with thin color, start to build up the highlights on each figure using a thick, dry mix of Titanium White, Alizarin Crimson, and Yellow Ochre and a medium-sized filbert bristle brush.

Materials

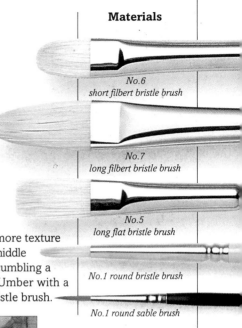

*No.6
short filbert bristle brush*

*No.7
long filbert bristle brush*

*No.5
long flat bristle brush*

No.1 round bristle brush

No.1 round sable brush

4 ▲ Use a small brush, such as a No.1 round bristle, to add finer details to the background and to create aerial perspective. These details should be painted over dry layers to avoid mixing paint.

5 ◀ Build more texture into the middle ground by scumbling a mix of Raw Umber with a small flat bristle brush.

6 ◀ Increase the sense of light falling across the scene with layers of light color over the initial washes. Using a cool mixture of Titanium White, Yellow Ochre, and a touch of Viridian, paint light gestural strokes over shadowed areas with a large filbert bristle brush. For warm areas add a little Alizarin Crimson instead of the Viridian.

7 ◀ Paint distant figures and objects with a cool brown, such as Raw Umber, using a fine brush, such as a No.1 sable round. When these details have dried, use even paler color in the background to increase the sense of aerial perspective and hazy light.

**Indian
Street Dwellers**
The look of this painting is clearly affected by the warm color of the toned ground, influencing the appearance of every hue in the composition. The finished look the ground gives allows the brushstrokes to be made quite sparingly, using paint thinned with turpentine to establish the scene, and thicker highlights to finish.

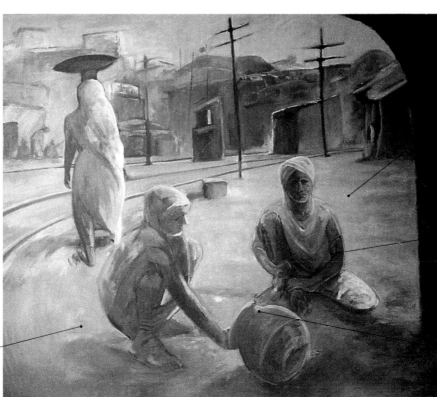

Shanti Thomas

The colored ground provides an effective base for subtle juxtapositions of warm and cool color to be laid on top of it.

Dark tones have been painted with thinner transparent colors, while the lighter tones and highlights have been created with thick opaque color.

The mid-toned ground links separate areas of color and gives an overall warmth to the painting.

Colored grounds give a more finished effect, allowing for a much looser and relaxed style of painting.

GALLERY OF WHITE & TONED GROUNDS

T HE PAINTINGS SHOWN HERE demonstrate how important the color of any ground is – from the bright clarity of color that can be produced on a white ground to the economy of painting on a subtle mid-toned ground. A toned ground not only affects the appearance of a color painted immediately on top of it, but also any successive layers of transparent and opaque paint.

Mick Rooney, RA, *Wedding Day Yalalag,* **1991** *36 x 28 in (91 x 71 cm)*
The principle of opaque highlights and transparent shadows on a dark ground is well illustrated in this painting of a village wedding. Opaque colors are worked stiffly in a scumbled dry brush technique that allows the dark ground color to show through in halftone effects.

Donald Hamilton Fraser, RA, *Grand Canal, Venice,* **1992** *30 x 23 in (76 x 58 cm)*
This is an excellent example of a painting made directly in an economical style on a white ground. The paint, applied thinly, allows the white ground to illuminate colors and give a clarity and sparkle to the quality of light in the painting. Areas of high contrast add a crisp brightness to the scene.

This detail shows how clean and strong the colors look on a white ground.

The glimpses of white ground still visible help to intensify the appearance of each color.

Pablo Picasso, *Head of a Sailor*, 1906-7 *15¾ x 16½ in (40 x 42 cm)*
The pastel-like quality of this work is due mainly to the fact that opaque white has been painted onto a dark ground and tinted with color. The colored ground shows through the brushstrokes, providing a strong backdrop to a subtle work. The effect of overlaying such a darkly colored background with an opaque dry brush technique pushes the simply styled image forward so that we feel even closer to the absorbed character.

In this detail the dark ground enhances simple blocks of color and the almost diagrammatical style of painting.

Thickly painted highlights over the dark ground make the work look more dramatic.

Paul Lewin, *Cornish Cliffs* *17½ x 20 in (44 x 51 cm)*
The brown mid-toned ground of this work has allowed for economy when painting and provides a warm, unifying background color to link the individual brushstrokes. The artist has employed thin transparent darks for the shadows and thicker opaque colors for the lighter tones, reserving the lightest tones and thickest paint for the breaking waves.

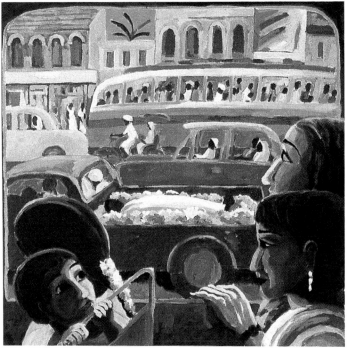

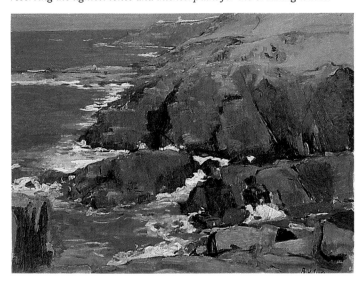

Jane Gifford, *Calcutta Bus Trip* *36 x 36 in (91 x 91 cm)*
This painting buzzes with warmth and humanity. It conveys the bustle and excitement of a busy Indian street in a series of relatively flat planes of bright saturated colors. Interlocking patterned shapes retain their clarity of color, having been painted directly onto the white ground.

ALLA PRIMA PAINTING

Establish a composition

ALSO KNOWN AS direct painting, alla prima work is usually completed in one sitting while the paint remains wet on the support. Such paintings have an expressive immediacy and freshness. It is important to bear in mind that once a color has been laid on, it will affect any color that is subsequently painted on top of it while it is still wet, so if you sketch in the broad areas of the subject first, do so with thin paint. You need a clear idea of where colors will be placed, or the painting will become muddy.

Sketching from life
Conditions constantly change when you paint from life; a landscape can alter dramatically if the sun goes behind a cloud, and people can move all too easily. Make plenty of preparatory sketches to explore your subject and collect handy reference material.

The feline characteristics of this cat have been captured with simple lines and a hint of color.

These economical studies are full of expression and interesting ideas.

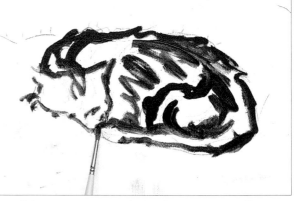

1 ▲ Cats can move away instantly, so use a small support to enable you to work across the canvas as fast as possible. Outline the shape of the cat using a small brush, such as a No.1 round bristle, and Ivory Black paint thinned with plenty of turpentine. Work quickly, making a line sketch to establish the position of the cat. Look for its essential features, keeping each brushstroke as loose and as expressive as possible. If you make a mistake, use the end of a cloth dipped in turpentine to wipe away the mark.

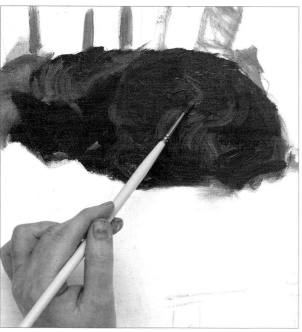

2 ◀ Plot the relationship of the cat to the cushion and armchair so that if the cat suddenly moves, the scale of the painting has already been planned. Then return to the cat and develop it as much as possible. Look for the way the light affects its distinguishing features, and which direction its fur grows. Describe the shape of the cat with a mixture of Ivory Black and Cerulean Blue, together with a little Titanium White. Flick the brush lightly to give the impression of fur.

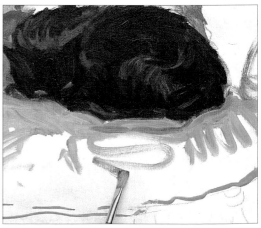

3 ▲ Use an orange mixed from Cadmium Yellow Deep, Cadmium Orange, and Titanium White to build up areas of the sketched cushion with light color. Avoid mixing in white paint when you fill in the darker areas of the cushion. Keep brushstrokes loose and full of expression to retain a sense of freshness.

4 ◀ Use a larger bristle brush to block in the color of the armchair and the wall behind. The broken color of the background must be cool and subdued so that it does not detract from the main subject. Take time to clean your brushes thoroughly before you apply each new color – working at this speed, you should guard against mistakes such as muddying your colors. Take the paint up to the edge of each separate area of color without overpainting.

5 ▶ Any gaps showing through in the canvas between broad areas of color can be covered up using a small bristle brush. Here the gaps can be covered by emphasizing the cat's wispy fur. Stroke touches of pure Cerulean Blue lightly over the first colors to give rich texture and definition to the cat.

6 ▶ Take a fine brush, such as a No.2 round sable, to deepen the shadows on the cat. Using a sable brush should allow you to apply fresh color over a layer of wet paint if you want to avoid mixing the two. Mix a small amount of Cerulean Blue paint with the Ivory Black to keep the shadows cool.

7 ▶ Work up the remaining areas of the composition once you are satisfied with the look of the cat. Deepen the folds and shadows of the cushion with pure Cadmium Orange. Use simple tonal variations of Yellow Ochre and Burnt Sienna to mold the wooden armchair.

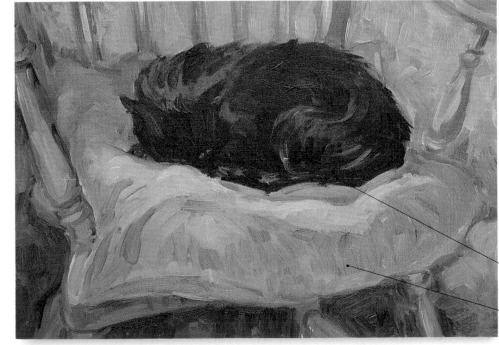

Cat on an Orange Cushion
This work has been planned in advance so that colors can be placed exactly without becoming muddy. The progress of the work has been geared around a subject that could move at any moment, without compromising the characteristic sense of immediacy associated with this style.

A strong composition is important if you are working quickly from life.

Colors are kept clean and pure, with simple variations in tone.

Sue Sareen

WORKING WITH A PAINTING KNIFE

IF YOU ARE UNACCUSTOMED to working with a painting knife, the first thing that will strike you is how different the paint feels on a knife compared to a brush. Working with a painting knife requires some delicacy, as it spreads the paint like butter onto bread; the flat surface of the painting knife seems to slice easily through the paint as you lay it onto the canvas. A paintbrush tends to come down onto the canvas vertically, while the painting knife can be applied horizontally, parallel to the surface of the painting. Painting knife studies are often made wet-in-wet, generally using more opaque colors.

Textured surfaces
A painting knife produces a variety of interesting textural effects simply by being held in different ways. If you want to increase the degree of texture on the surface of your support, mix some dry sand into the primer when you prepare the board. This builds up the surface of the support into a relief, pushing the painting into three dimensions.

Using a painting knife
A painting knife needs to be used with confidence and without hesitation, so it is worth practicing first. Use a knife both for building up final highlights in thick impasto and for a textured, lively painting. Painting knives are not the same as palette knives, which are only intended for mixing paint and cleaning palettes; painting knives have a bend in the handle so that they can be held in several different ways to manipulate the creamy paint into expressive shapes (*see below*). Many artists use their finger on the springy blade, pushing it down deliberately to control the way the paint is applied. Since paint is usually applied very thickly with a painting knife, it is sensible to work on a rigid support.

Horizontal strokes of thick, creamy paint from a loaded painting knife.

Small dabs of color are useful for details.

Use this technique to build up a regular pattern of texture.

Use the length of the blade to smear paint over a surface.

Press gently into the paint with a finger on the back of the blade.

Bold strokes
Grip the handle firmly, as you would a trowel, and paint decisive, vigorous strokes of color across the surface of the support.

Light effects
For a lighter control of the painting knife, place your index finger on the springy part of the blade so that just the tip presses down into the paint.

A firm but even grip gives good control.

Wrap your fingers firmly around the wooden handle.

Clean lines
A more common way of holding the knife is to place your index finger on the end of the wooden handle and push the metal shaft into the paint. This produces a firm imprint of the blade in the paint and is useful for making ridged lines of color.

1 ◄ This portrait is built up on a small primed panel so that the paint can be scraped easily to give a more textural study. Make a quick sketch first with thinned paint if you need to work out correct proportions. Then smooth paint over the main areas of the portrait with light strokes.

2 ◄ When you have applied different tones to the face and hair, use the edge of the painting knife, or a bit of cardboard with serrated edges, to emphasize the direction the hair grows in. These create highlights on the hair and help to break up heavy layers of paint.

3 ▷ Smooth a clean finger gently over any area where you need to blend the paint; a painting knife is effective for crisp lines of color, but it may be difficult to achieve the same degree of subtle blending that can be produced with a brush or a finger.

Materials

Diamond-shaped painting knife

Serrated edge

Paintbrush handle

4 ◄ Use the end of the painting knifc, or thc tip of a brush handle, if you want to make small dots of color and build up the texture of the painting. Dip the brush handle in paint and use it to suggest the pattern of this cardigan.

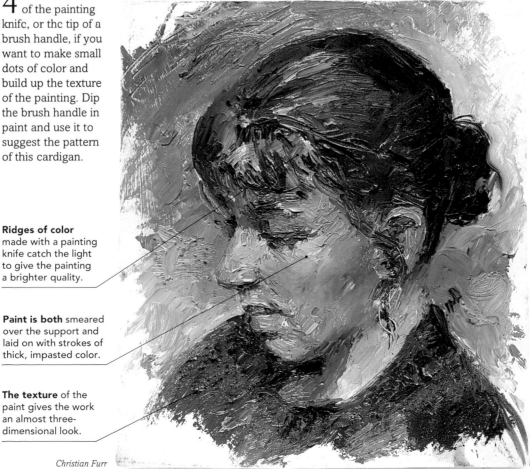

Ridges of color made with a painting knife catch the light to give the painting a brighter quality.

Paint is both smeared over the support and laid on with strokes of thick, impasted color.

The texture of the paint gives the work an almost three-dimensional look.

Christian Furr

Textural portrait

A variety of expressive textural marks give this portrait life. A painting knife is used to apply the paint quickly and produce crisp strokes of color to establish the main features of the face. Additional techniques, such as lines and highlights made with a serrated edge and dabs of paint made with a brush handle, add to the textural surface. The painting knife has been used finally to apply thick impasted highlights.

GALLERY OF ALLA PRIMA PAINTINGS

OIL PAINT IS SUCH a versatile and valuable material that it may be used in a variety of rich textural effects and brushstrokes. Painting from life can encourage this sense of freedom and expression when you work with oil paint, as it relies on a freshness and immediacy. Brushstrokes and marks appear more tangible if they have been painted wet-in-wet, or wiped off and reapplied, and the paintings shown here are examples of the wide-ranging results and instant appeal that can be achieved by incorporating different techniques and textural effects.

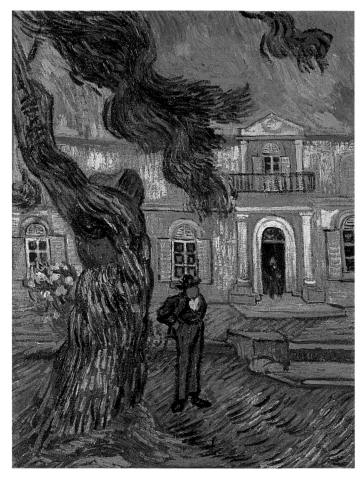

Vincent van Gogh, *The Hospital Garden at St. Rémy,* **1889** *25 x 18 in (63 x 48 cm)*
It would be difficult to make a more immediate statement in paint than this work by Van Gogh. Strong, stubby brushstrokes follow the forms of the painted objects, and the ground appears to move like a sea. The texture and rhythm of the brushstrokes across the surface of the painting give the scene an intense energy.

This detail shows particles of sand, blown by the wind, still embedded in the paintwork. The fluent brushwork seems to echo this tugging wind.

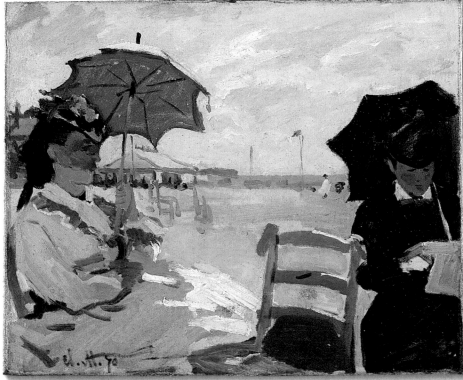

Claude Monet, *The Beach at Trouville,* **1870** *14¾ x 18 in (38 x 46 cm)*
This study was painted rapidly on the beach at Trouville. Built over a warm, pale gray ground, the work is striking in its immediacy and in the fluent brushwork. There is also much of the wet-in-wet work so characteristic of Monet, with fresh colors laid into one another.

Ken Howard, RA, *Blue and Gold Kimono,* **1991** *40 x 48 in (102 x 122 cm)*
The freshness of the brushwork in this scene gives a lively quality, although there is control in the painting style. The screen, for example, is carefully painted to give a loose, free impression. Broad planes of light and dark allow the artist to incorporate detail without overloading the composition. It is important to stress this idea of control in what comes across as a very spontaneous work.

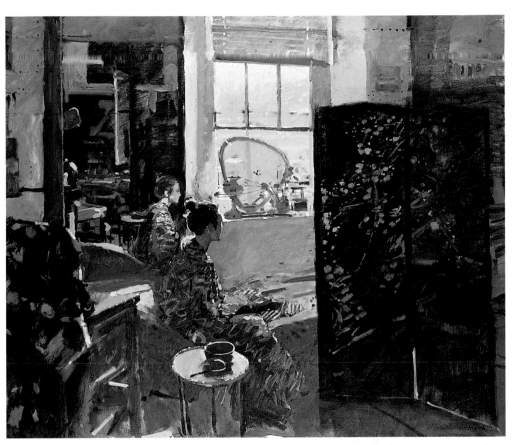

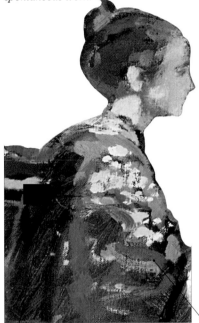

The subtle pattern on this kimono is echoed in other areas of the painting.

This detail shows both the vigor and the control in the individual brushstrokes that create the pattern on the kimono.

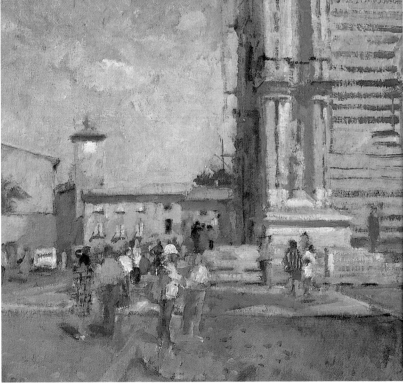

Julian Schnabel, *The Geography Lesson,* **1980** *88 x 84 in (224 x 214 cm)*
The buttery texture of oil on velvet in this work is heightened by impasted strokes of vivid color. The subject matter is perfectly matched by the painting style.

Bernard Dunstan, RA,
Piazza del Duomo, Orvieto,
*c.***1991** *14½ x 15¾ in (37 x 40 cm)*
This painting has an assurance of touch and economy, giving a relaxed quality and a real sense of space and light.

PAINTING IN LAYERS

IF YOU ARE NOT USED to building up a painting in layers, you should keep two things in mind. First, always wait until a paint layer is completely dry before overpainting it with another color, and second, add a drop or two more of your oil painting medium to your paint mixtures as you work up through the layers of color. This ensures that each layer is slightly more flexible than the one below, and is known as the "fat-over-lean" rule. Although there are many ways of painting in layers, one method is to sketch an image in diluted color and then paint in the broad areas of tone with a transparent or monochromatic technique. When this is dry, color can be added and paler tones worked in. Once these layers are dry, final applications of transparent glazes and opaque highlights can be added.

APPLYING A GLAZE

Transparent oil glazes should not simply be brushed on and left; they usually have to be manipulated with a brush on the support to give a uniformity of tone, even out the degree of color saturation, or reduce a thick glaze to a light stain. A blending brush, or a clean shaving brush, is good for dabbing and smoothing the glaze. When you mix a glaze, add a glazing or painting medium to the paint to make it more malleable. Once you have painted on the glaze, wait for a few moments so that some of the solvent in the painting medium can evaporate. Then use the shaving brush to manipulate the glaze and smooth away visible brushmarks. If you only need to glaze a small area, use a small round or flat soft hair brush instead.

1 *An underpainting in one color can be useful as it allows you to concentrate on form and tone first, rather than color.*

2 *Once the underpainting is dry, apply color over the different tones with a large bristle brush.*

3 *Smooth the glaze over the surface with a large, flat round brush, such as a shaving brush.*

Building up layers of color

A still life is a good subject to choose if you want to practice painting in layers, because you can leave the composition set up for as long as you need while you wait for individual layers of paint to dry. This study is built up over a colored ground to give the layers of color a subtle accent. A monochromatic underpainting helps to establish areas of light and dark before any colors are applied. Mix each glaze you use with a little oil painting medium.

1 ◀ Sketch the composition in with a thin mix of Burnt Umber and then use a small round bristle brush and a range of gray tones to build up a tonal picture of each object in this still life.

2 ▲ When the underpainting has dried, mix individual glazes of color and apply them with a large, flat, synthetic wash brush. If you prefer, use a new brush for every glaze so that you can retain the purity of each color.

3 ▷ When the first glazes are dry, mix a darker glaze of Permanent Red for the red stripes on the rug, adding a little more painting medium to increase the amount of oil in the next layer. Apply the deep transparent color with a medium-sized bristle brush, and as these areas of red are quite small, use a sable brush to work the glaze to a smooth finish.

4 ◁ Add thin layers of strong color to each object using a medium-sized brush, such as a No.6 long filbert bristle. Dab the glaze gently with the round sable brush to manipulate the glaze and smooth away any uneven areas of paint. If paint builds up on the brush, wipe it off on a piece of absorbent tissue, or if you paint over any highlights, use the cloth to wipe away the unwanted paint.

5 ▲ Add a final glaze to the back wall with a large bristle brush to give a cooler, more shadowy effect. Use a clean, dry shaving brush to work the glaze in with short strokes.

Studio still life
This painting has been built up with layers of thin color. The colored ground provides a warm base for transparent glazes that are applied only after previous layers are thoroughly dry. Glazes over large areas are smoothed into a uniform tone with a shaving brush.

The tones on each object have been achieved with an underpainting.

Separate layers of transparent color together give a rich, luminous effect.

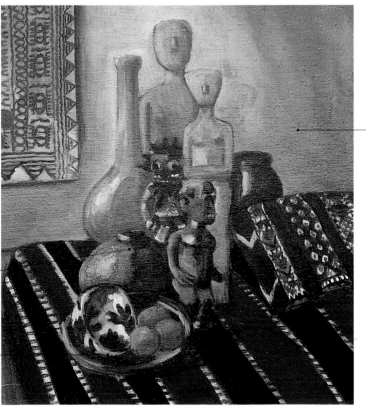

The large area of the back wall is glazed with cool color so that it appears to recede behind the still life.

Ian McCaughrean

Materials

No.1 round bristle brush

No.6 short filbert bristle brush

No.6 long flat bristle brush

1¼ in synthetic wash brush

Shaving brush

PAINTING IN STAGES

Preparatory sketch from life

THERE IS OFTEN an overlap of two or more techniques in any work. Although some paintings appear to have been painted directly from life, they may also have been built up with careful final stages to heighten the tone and effect of colors, or to increase the element of detail. The work below has all the hallmarks of a painting from life, although in fact it has been built up in a series of carefully planned stages. In this kind of transitional painting, it is usual to begin by blocking in major areas of tone and color, and then working into these with deeper glazes and more detail as the painting develops. The most important aspect of this process is that you add a new layer of paint only after the last layer is dry. A white ground retains the power and clarity of every color.

1 ▷ Make a light sketch of the composition in charcoal, working out the position of trees and plants. If the lines look too harsh, try brushing off the excess charcoal with a soft hair brush or a piece of doughy bread (*see* pp.40-41). Excess charcoal can muddy the paint if it is left lying on the surface of the canvas, so another way to protect the paint is to spray a surface coating of fixative over the charcoal outlines.

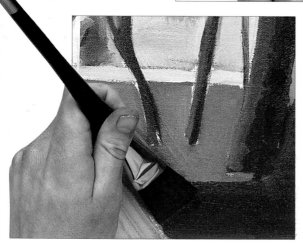

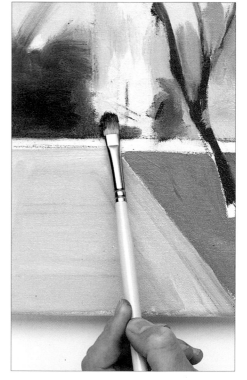

2 ▷ Block in the main areas of the painting with thin areas of pure, bright color using a large or medium-sized bristle brush. Leave these first layers to dry before adding new paint.

3 ▲ Once the first layers of thin paint are dry, deepen separate areas of color. Use a large synthetic wash brush to lay a thin, transparent glaze of Permanent Rose over the foreground area to deepen its tone. Mix a little oil painting medium into the Permanent Rose so that it can be manipulated more easily on the canvas. Use a clean, dry, soft hair brush to brush the glaze into a uniform consistency over the canvas.

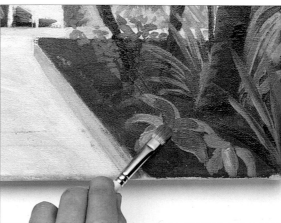

4 ◁ Use a long filbert bristle brush to paint in branches and leaves. Use cool colors for areas in shadow and a transparent mix of Winsor Green for brighter details to create a sense of distance and capture the airy spaciousness of this conservatory.

5 ◀ Once the layers of paint are dry again, start adding in details of the foliage. This is time-consuming work, as the trees and leaves should be painted individually to create movement and depth in the painting. Emphasize bark on the tree trunks by painting cool blue shadows using a small synthetic or sable brush.

6 ▶ The ironwork across the roof and the path down the center hold the composition together, so paint them with strong, clean colors to create visual impact. Use a small flat brush to paint the gratings on the path, and a small round synthetic brush to heighten the smooth, metallic look of the ironwork beyond.

7 ▶ Finally, give the feeling of space by painting in small leaves with dabs of pale, cool blue paint over the iron arch, which should help to push it farther into the background. Darken areas in shadow if you need to increase the contrast of tones and colors that heighten the feeling of bright light in the painting.

The Palm House

The greenhouse atmosphere in this painting has been created using a white ground to keep the colors strong and retain a sense of immediacy. However, the paint has been built up in stages to increase the detailed look of the foliage and deepen the tone of transparent colors.

A white priming keeps colors strong and bright.

Touches of white paint give the impression of strong light shining through the roof.

Thick strokes of impasted color have been painted last to give texture and definition.

Thin glazes of transparent color deepen the tone of the foreground.

Ian McCaughrean

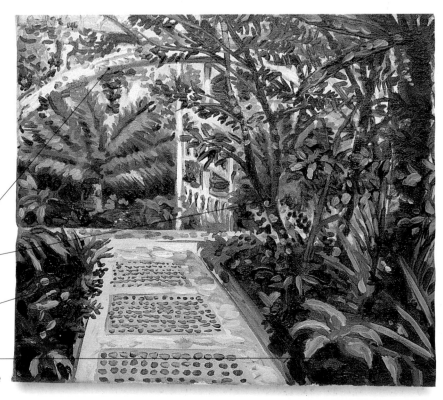

Materials

Charcoal

No.8 long flat synthetic brush

No.6 round sable brush

No.6 long filbert bristle brush

1½ inch mixed fiber wash brush

GALLERY OF PAINTING IN LAYERS

PAINTING IN LAYERS has been integral to the art of painting for hundreds of years, and some systematic methods have evolved. The key to this technique is that each layer of paint must be completely dry before more paint is applied. There are variations on this theme, ranging from refining a simple painting with highlights and shadows, to a more complex interweaving of transparent and opaque layers of paint to create sophisticated effects. Artists evolve their own methods of working, and the images here represent a variety of approaches.

Giovanni Moroni,
Portrait of a Widower with His Two Children, c.1565,
38½ x 49½ in (98 x 126 cm)
This painting has been layered in stages over a warm ground, and the depth of tone – so relevant to the meaning of the work – has been built up with transparent glazes. Bright pale tones are stacked up in opaque color to provide contrast with the background. A dramatic poignancy arises from the juxtaposition of pure, primary colors on the children's skirts with the widower's dark costume and background.

Shanti Thomas,
Fruit Stall, *26 x 30 in (66 x 76 cm)*
This is an example of a work that gives a strong, direct, and immediate impression, but was in fact built up in stages. The painting relies on overlaid touches of transparent, semi-opaque, and opaque paints in a patchwork of color to create contrasted areas of tone and rich surface effects.

Ray Smith,
Dr. McDonald,
36 x 27 in (91 x 69 cm)
Painted on a dark-toned background, the attention of this work focuses sharply on the bright, wrinkled face of the man. Dark areas have been worked up with transparent glazes and highlights with opaque color.

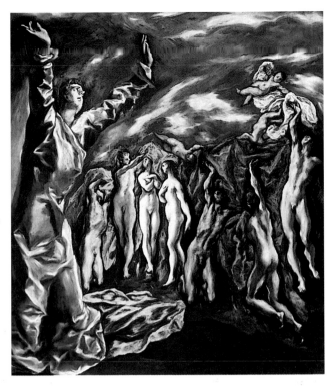

El Greco, *Vision of St. John,* 1610-14
87½ x 76¼ in (222 x 194 cm)
El Greco may have modeled his drapery while the transparent glazes were still wet, reversing established practices and proving that there are no hard and fast rules in painting.

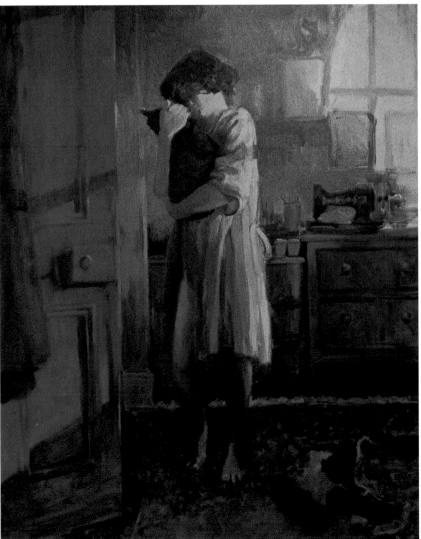

Sue Sareen,
Young Girl With a Cat, *36 x 28 in (91 x 71 cm)*
This painting of the artist's daughter was developed indirectly in a few simple stages. The composition was both painted from life, and worked on from four separate photographs. The image was first drawn in charcoal and then sketched on top in Burnt Umber. Colors were then blocked in thinly and left to dry. The painting was finished two weeks later when the colors were built up in a more solid application.

A large area of Cadmium Red paint on the open door is echoed in other areas of the painting. This detail shows light strokes of Cadmium Red illuminating the girl's hair.

Touches of Cerulean Blue provide cool notes throughout the painting and offset the large areas of red.

EXPERIMENTAL TECHNIQUES

ARTISTS HAVE ALWAYS EXPERIMENTED with different ways of working with oil paint. One traditional technique is sgraffito, in which one color is laid over another layer of dry color and then scratched through with a sharp instrument so that the color beneath is revealed as an image or pattern. Another technique is to paint or splash thick colors onto a canvas or board, lay a sheet of thin, hard paper or plastic over the top, lift some of the paint off, and use the remaining image for special textural or surreal effects. Nowadays, there are also new materials developed by manufacturers. A relatively recent product is the oil stick, which is basically oil paint in stick form. This allows you to draw with the oil paint as though it were a pastel or a piece of charcoal. It has a smooth, creamy feel and it is possible to work it into a wet color and still retain the color of the stroke you are making.

Sgraffito

Sgraffito is an old method of drawing into a layer of wet paint to produce a line drawing of an image or a detail. When you scratch through the layer of wet paint you should reveal a new color underneath, whether it is another layer of dried paint, or the canvas or board itself. Here, a thick layer of blue paint has been applied with a painting knife, and the blade of the knife then used as the drawing instrument. You can use all kinds of tools for this technique; a screwdriver, for instance, will give a line similar to that made by drawing with a carpenter's pencil. Many artists whittle the end of an old paintbrush for sgraffito effects as the softer wood is less likely to damage the canvas.

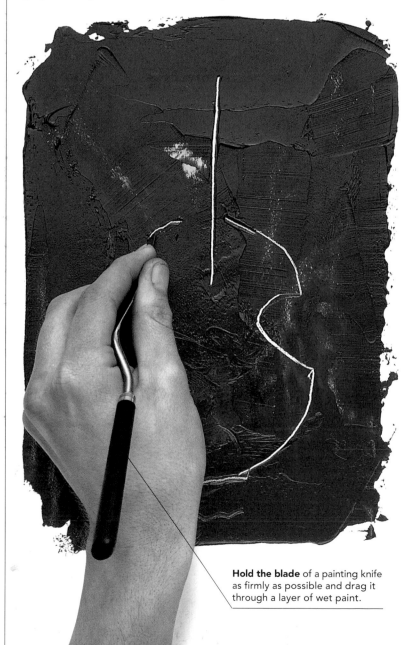

Hold the blade of a painting knife as firmly as possible and drag it through a layer of wet paint.

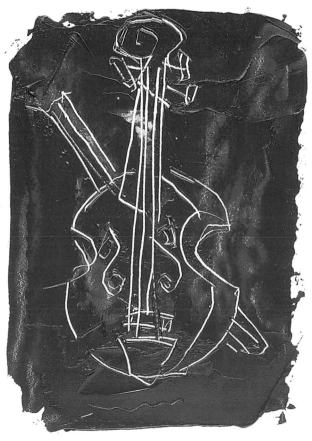

OIL STICKS

Oil sticks are a type of oil paint blended with waxes and applied directly onto the canvas. You can dispense with brushes entirely, modifying colors with a piece of cloth or a finger. Oil sticks are unlike other drawing materials in that they are extremely creamy in texture. They are good for working wet-in-wet, so you can apply one wet color over another without making a muddy mixture. In this study of a carnival mask, the background has been rubbed with a cloth dipped in turpentine and the other colors left unmodified.

Use a tape with a low tack adhesive, such as masking tape or drafting tape.

Masking tape
If you want to paint a very straight edge, use masking tape. Ensure that the color you lay the tape onto is dry, and that the tape is not too strong. Pull it away carefully, or it may pull off the paint beneath it.

Modifying a painted surface
Modify the surface of an oil painting if you want to remove excess color or adapt the overall effect. One method, which is also a form of monoprinting, is to lay a sheet of paper over an area of paint, rub it gently with your hand, and pull it off slowly. Use a damp, absorbent paper if you want to remove plenty of paint.

If you want to make a monoprint, paint an image on a slab of glass and take a print of it using absorbent paper.

VARNISHING & FRAMING

Choosing a frame
A frame can alter the look of a painting quite significantly, so try to choose from a wide selection of frame samples.

A FILM OF VARNISH PROTECTS an oil work from atmospheric pollution and abrasion. A gloss varnish can also bring out the colors in a work, giving them a greater saturation and depth, and so heightening the impact of the picture. A varnish is actually a solution of resin in a solvent, and the resin forms a hard but flexible protective film after the solvent has evaporated.

A frame can have a significant impact on a work, giving it a focus that can either detract from its appearance, or allow it to be seen at its best. You should choose a frame with care and decide whether you make it yourself or have it made professionally; the appearance of a painting can easily be ruined by a badly made frame with its corners out of alignment.

Materials

Cotton ball

Varnish

Flat bristle brush

Tape measure

Varnishing

A painting should be completely dry before varnishing, so it is advisable to leave it for about three months. You can make an acceptable varnish by dissolving dammar resin in turpentine, but most artists buy a good quality dammar varnish for a high gloss look, or ketone varnish for a less yellowing effect. The painting must also be free from dust, dirt, and grease, which can cause the varnish to form a blotchy surface. Make sure the room you choose to work in is well ventilated and warm.

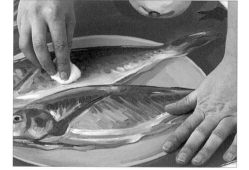

1 ▲ Lay your dry painting on a flat surface and clean it with a cotton ball moistened with saliva – an excellent cleaning agent. This should ensure that the painting is completely clear of dust and grease.

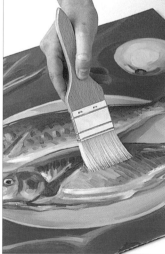

2 ◀ Apply a coat of varnish with a flat bristle brush (you can buy special varnishing brushes from artists' suppliers), making parallel strokes in one direction across the painting. When the first layer of varnish is dry, apply a second coat with the same varnishing brush, working at right angles to the first coat. This produces a fine, even film of varnish.

Framing

It can be hard to produce a well-made frame, so if you feel at all unsure about making your own, use a professional framemaker. Choose a frame that best suits the style of your painting. If the work is bright and vigorously painted, choose a bold, simple frame.

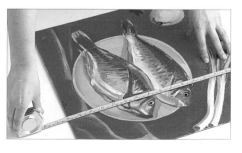

1 ◀ Measure the height and width of the painting with a tape measure. You should be as precise as possible so that the frame can then be cut to fit the painting exactly.

2 ▷ The measurements of the painting form the inside lengths of the frame, so measure off the correct height and width on four pieces of molding and cut 45-degree angles at either end. You can use a special miter cutter, but this is an expensive piece of equipment, so a simple miter box is a good alternative (*right*). Fit a tenon saw into the prepared grooves of the miter box and cut the required angle.

3 ◁ Spread a special wood glue over the sawned edges of two pieces of molding to form one corner of the frame. This must be held firmly in place until the glue has dried, so use a corner clamp to hold the pieces of wood in a rigid position.

4 ▷ Tap in brads on either side of the corner with a hammer, and then drive the brads right into the wood using a nail punch.

6 ◁ Finally, seal the back of the frame and cover all the brads using gum tape around the edges.

5 ▲ Once all four corners have been secured, place the painting in the frame, cut out a piece of hardboard the same size as the painting, and slot it in the back. Drive in some more brads to tighten the board.

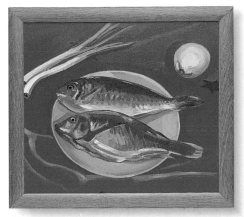

Changing the look of a painting

This work is shown with two different moldings to illustrate how a frame changes the shape and look of a painting. Choose certain colors or textures to enhance a painting. Avoid brightly colored frames for subtle, low-key paintings.

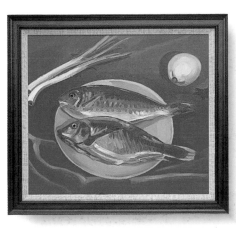

Materials

Miter box

Tenon saw

Wood glue

Hammer

Brads

Nail punch

Gum tape

Hardboard

Molding

GLOSSARY

ADJACENT COLORS Those colors literally closest to each other on the color wheel; also used to describe colors that lie next to one another in a painting. Adjacent complementary colors appear brighter together because each reinforces the effect of the other.

ADVANCING COLOR The perception of a color, usually warm (orange-red), as being close to the viewer.

AERIAL PERSPECTIVE This describes the effect of atmospheric conditions on our perception of the tone and color of distant objects. As objects recede toward the horizon they appear lighter in tone and more blue due to the scattering of light in the atmosphere. Artists tend to use a cool color such as blue to paint objects viewed in the distance to achieve a sense of space. Some artists like to work from the palest tones through to the darkest tones in the foreground to create distance and depth. This principle is used particularly in landscape painting.

ALLA PRIMA Literally means "at first" and is a direct form of painting made in one session or while the colors remain wet. (As opposed to "indirect" painting in which the painting is built up in layers). This is the technique employed by artists when they want to paint spontaneously. It is, however,

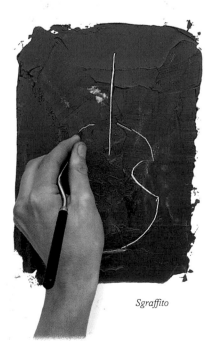

Sgraffito

a difficult style to master as it requires fluent brushstrokes and a skillful manipulation of the paint.

BINDER In a paint, this is the substance that holds the pigment particles together and that acts as an adhesive to the support (*see also* extender).

BLENDING A soft, gradual transition from one color or tone to another. A clean, dry brush should be used to make gentle strokes in the same direction to join separate colors. Blending may involve slightly softening the sharp outline of a single object against a background, or working on the whole painting, so that it takes on a rounded, seemingly three-dimensional effect.

BRISTLE BRUSHES Hog hair or bristle brushes are used extensively in oil painting. They have coarse hairs which hold plenty of thick paint and yet retain their shape. Bristle brushes are useful for covering large areas with a uniform tone and for blending.

BROKEN COLOR Color that has been broken up by mixing with another color or affected optically by the juxtaposition or superimposition of another color. Broken color can be created using a dry brush or scumbling technique.

CHALK Natural calcium carbonate, used in the preparation of chalk/glue grounds for its whiteness and opacity and as a cheap extender in oil-based paints in which it is translucent. "Chalking" is the powdering of the paint surface due to the breakdown of the binder as a result of ultraviolet radiation.

CHARCOAL Carbonized wood made by charring willow, vine, or other twigs in airtight containers. Charcoal is one of the oldest drawing materials. If charcoal is used for a preparatory drawing, the excess dust can be rubbed off the surface using a large soft hair brush or a piece of doughy bread.

Drawing grid

CHROMA The intensity or saturation of a color. Chromatic is the term used for an image that has been drawn or painted in a range of different colors.

COLOR TEMPERATURE A measurement of color in degrees Kelvin. This is also of importance to photographers, who need to correlate the color temperature of a light source with the type of film they use. As artists we are aware that the color temperature of a room illuminated by electric light is significantly different from (yellower than) that of daylight.

COMPLEMENTARY COLOR Two colors of maximum contrast opposite each other on the color wheel. The complementary of a primary color is the combination of the two remaining primary colors. For example, the complementary of blue is orange-red, the opposite of red is green, and the complement of yellow is violet.

COOL COLOR Generally, a color such as blue is considered cool. Distant colors appear bluer due to atmospheric effects, so cool colors are therefore said to recede.

DAMMAR A soft resin soluble in turpentine and used to make a gloss varnish. You can make an acceptable varnish by dissolving some dammar resin in a jar of turpentine or white spirit.

DARKS Those parts of a painting that are in shadow.

DIRECT PAINTING *See* alla prima.

DRAGGED Describes brushstrokes that are made across the textured surface of canvas or paint or at a shallow angle into wet paint.

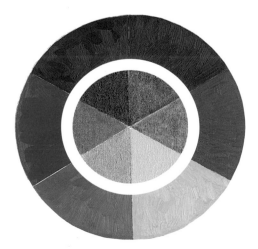

Color wheel

DRAWING GRID A drawing grid is made up of a series of squares that enable an artist to transfer a sketch proportionately onto a large-scale support. The grid can easily be produced by drawing squares onto a piece of acetate or tracing paper and then laid over the sketch.

DRY BRUSH TECHNIQUE A method of painting in which paint of a dry or stiff consistency is stroked or rubbed across the canvas. It is picked up on the ridges of the canvas or by the texture of paint on the surface, leaving some of the color on the canvas still visible and producing a broken color effect (*see also* scumbling).

EASEL A frame for holding a painting while the artist works on it. Landscape painters tend to use sketching easels, which are of a light construction. A good sketching easel allows the painting to be held securely in any position from vertical to horizontal. The heavy radial studio easel and vertical studio easel are suitable for studio work.

EXTENDER A pigment which has a limited effect on a color. It may be added to control the properties of a paint or to reduce the cost. Examples are chalk and china clay.

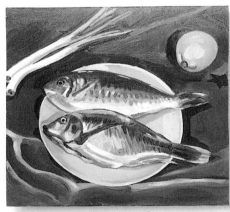
High-key color

Low-key color

FAT-OVER-LEAN The rule applying to oil painting in layers, in which each superimposed layer should have a little more oil in the paint than the one beneath. This ensures that each layer is more flexible as a dried film than the one below it, with less risk of the paint cracking.

FERRULE The metal part of a brush which surrounds and retains the hairs.

FIXATIVE A surface coating which prevents charcoal, chalk, and Conté crayon from becoming dusty and from mixing with overlaid color.

FLAT COLOR An area of matte color of uniform tone and hue.

FUGITIVE Colors that are not lightfast and will fade over a period of time.

GESSO A traditional ground for tempera and oil painting on panel comprising animal glue (rabbit skin glue) and plaster of paris. In northern Europe, chalk and glue were used for the same purpose. Not to be confused with the product acrylic gesso (primer), which is also commonly available as a primer for acrylic painting.

GLAZE A film of transparent or translucent oil color laid over another dried color or underpainting. The oil paint is usually mixed with an oil painting medium to make it more malleable.

GROUND The surface on which color is applied. This is usually the coating rather than the support. A colored ground is useful for low-key paintings where the ground provides the halftones and the unifying element for the different colors. A colored ground can also be applied as an imprimatura, or as a primer that has been colored.

HALFTONES Transitional tones between the highlights and the darks.

Stretching a canvas

HATCHING Making tonal gradations by shading with long, thin brushstrokes. Often used in underpainting.

HEEL OF BRUSH The base of the hairs near the ferrule.

HIGH-KEY COLOR Brilliant and saturated color. Some oil colors, especially the transparent ones, are dark when used directly from the tube, so a little white can be mixed with them to give a saturated color effect. Alternatively, such colors can be used thinly on a white ground for a similar high-key look. High key paintings are usually painted on white or near-white grounds.

HIGHLIGHT The lightest tone in drawing or painting. In oil painting techniques, white constitutes the lightest tone.

HUE Describes the actual color of an object or substance. Its hue may be red, yellow, blue, green, and so on.

IMPASTO A thick layer of paint, often applied with a painting knife or a bristle brush, which is heaped up in ridges to create a heavily textured surface and a look of fresh immediacy. Artists often scrape the paint off the surface of the support and apply the color again if it does not retain the crispness of the effect required.

IMPRIMATURA A thin overall film or stain of translucent color over a white priming. This is applied before the artist begins to paint. It does not affect the reflective qualities of the ground, but it provides a useful background color and makes it easier to paint between the lights and darks. It also allows for an economical style.

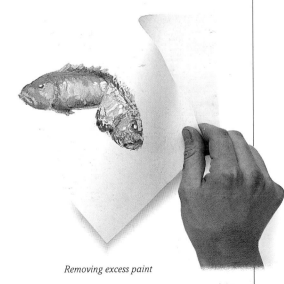
Removing excess paint

LAY IN The initial painting stage over a preliminary drawing where the colors are applied as broad areas of flat color. This technique is also known as blocking in.

LIGHTFASTNESS The permanence or durability of a color.

LINSEED OIL A vegetable drying oil from the seeds of the flax plant used as a binding material in oil color. Linseed oil is the most commonly used oils and it dries more quickly than semidrying oils. The oil does not dry by evaporation but forms a solid film.

LOW-KEY COLOR Subdued, unsaturated color that tends toward brown and gray. Tertiary colors are low-key in appearance and produce neutral hues similar in mood and tone.

MAHL STICK A bamboo or aluminum stick about 4ft (1.25m) long with a ball-shaped end. If you paint with your right hand, the stick is held with the left hand, with the ball end touching the canvas so that the right hand can rest on the stick while painting. This helps hold your hand steady if you need to work on a particular area.

MASKING TAPE Pressure-sensitive tape used to protect areas from paint.

MEDIUM The binding material or "vehicle" for pigment in a paint system. In oil paint, a vegetable drying oil such as linseed oil is the medium. An oil painting medium is used to modify the consistency of oil paint in techniques such as glazing. A typical oil painting medium is made up of a mixture of stand oil (linseed oil that has been boiled) and turpentine.

MONOPRINT A unique print taken from a work created on a slab of glass or laminate.

OIL STICKS A type of oil paint blended with waxes in the form of sticks and applied directly to the canvas. Colors can be modified with a piece of cloth or a finger. Oil sticks, unlike other drawing materials, are extremely creamy in texture and are good for working wet-in-wet.

OPAQUE PAINTING Paintings that use predominantly opaque paints and the techniques associated with them.

OPTICAL MIX When a color is arrived at by the visual effect of overlaying or abutting distinct colors, rather than by physically mixing them on a palette.

PERSPECTIVE The method of representing a three-dimensional object on a two-dimensional surface. Linear perspective makes objects appear smaller as they get farther away by means of a geometric system of measurement.

PHTHALOCYANINE Modern organic transparent blue and green (chlorinated copper phthalocyanine) pigments of high tinting strengths and excellent lightfastness. Also known by trade names.

PHYSICAL MIX When a color is created by premixing two or more colors together on the palette before application to the support. Wet-in-wet and wet-on-dry techniques refer to mixing paints on the support itself.

PIGMENT A solid colored material, in the form of discrete particles, which forms the basic component of all types of paint. In oil painting, pigments are bound together with a semidrying or drying oil, such as linseed oil. Pigments come in different forms and the amount of oil used to coat each type of pigment will vary.

PLEIN AIR This term refers to painting in the open air. Alla prima techniques are normally used in this situation.

PRIMARY COLORS The three colors of red, blue, and yellow in painting that cannot be produced by mixing any other colors.

PRIMING This refers to the preliminary coating laid onto the support prior to painting. A layer of priming protects the support from any potentially damaging components of paint and provides the surface with the right key, absorbency, and color before painting.

RECEDING COLOR The perception of a color, usually a cool (blue), as being distant from the viewer.

REFRACTIVE INDEX A measure of the degree of refraction of a substance. The ratio between the angle of the incident ray in air with that of the refracted ray in the substance produces this measure.

SGRAFFITO A technique, usually involving a scalpel or a sharp knife, in which dried paint is scraped off the painted surface so that the color of the surface, or a dry color painted previously, is visible. This is often used for textural effects.

SABLE BRUSH Mink tail hair used to make fine brushes. Normally used in watercolor techniques, these brushes can also be used in oil painting for fine detailed brushwork or final touches and highlights.

SATURATION The degree of intensity of a color. Colors can be saturated, i.e., vivid and of intense hue, or unsaturated, i.e., dull, tending toward gray.

SCUMBLING A painting technique in which semi-opaque or thin opaque colors are

Ready-primed canvas

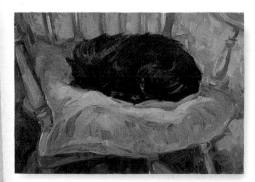

Alla prima

Viewfinder

loosely brushed over an underpainted area so that patches of the color beneath show through

SECONDARY COLORS The colors arrived at by mixing two primaries, i.e., blue and yellow make green, red and yellow make orange, and red and blue make violet. However, if different proportions of each primary color are combined, a range of tones of the secondary color can be produced.

SHADE Color mixed with black.

SIZE Rabbit skin or other glue used to protect canvas from the potentially damaging effects of oil in the paint before priming and to seal or reduce the absorbency of wooden panels. The binding material for gesso.

SOFT HAIR BRUSHES These are used mainly in watercolor painting but are also suitable for precise brushwork in oil painting. They can hold a great deal of thin paint while still retaining their shape.

STRETCHER The wooden frame on which a canvas is stretched.

SUPPORT The material on which a painting is made. Almost any surface can be used, but artists tend to use either a wooden panel or a canvas to work on. These materials are available in a range of textures and weights.

TERTIARY COLOR A color that contains a proportion of each of the three primaries (*see also* unsaturated color).

TINT Color mixed with white. "Tinting strength" is the strength of a particular color or pigment.

TONE The degree of darkness or lightness of a color. Crumpling a piece of white paper allows you to see a range of tonal contrast.

TONED GROUND Also called a colored ground. An opaque layer of colored paint

Working on a white ground

of uniform tone applied over the priming before starting the painting.

TRANSPARENT PAINTING A painting technique that relies on the transparency of the paints used.

TURPENTINE (DISTILLED) Used to thin oil color and to make resin varnishes such as dammar varnish. Turpentine is also used as an ingredient in a number of oil painting mediums. White spirit can be used instead of turpentine.

UNSATURATED COLOR Sometimes known as desaturated color. A pure, saturated color becomes unsaturated when mixed with another color into a tint or a shade. When three colors are mixed together in unequal amounts, the resultant color can be called a colored neutral.

VALUE The extent to which a color reflects or transmits light.

VARNISH Protective surface over a finished painting imparting a glossy or matte surface appearance to a painting.

VIEWFINDER A rectangular hole to the scale of the artist's support, cut in a small piece of cardboard to act as a framing device. This is held up at arm's length so that the scene to be drawn or painted can be viewed through it and the most pleasing composition can be found.

VISCOSITY A measure of the flow characteristic of a color or medium (e.g., stand oil is more viscous than alkali-refined linseed oil). Oil paint with some viscosity is described as having body.

Bristle brushes

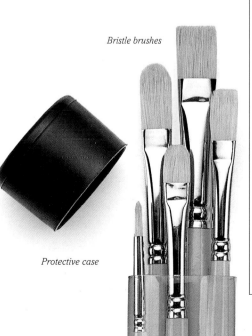

Protective case

WARM COLOR Generally, a color such as orange-red is considered warm. In accordance with atmospheric or aerial perspective, warm colors appear to advance toward the viewer.

WET-IN-WET Working with wet paint into wet paint on the surface of the support.

WET-ON-DRY Applying a layer of wet paint onto a dry surface.

Proportion of oil to pigment

A NOTE ON COLORS, PIGMENTS, AND TOXICITY

In recommending Winsor Blue and Winsor Green (which are trade names of the Winsor & Newton Company) we are recommending "Phthalocyanine" pigments; other artists' material manufacturers refer to them by their own trade names. These include Phthalo Blue and Green, Monestial Blue and Green, and so on. Similarly, in recommending Permanent Rose we are recommending a "Quinacridone" pigment. If you have any doubts about which pigment you are buying, refer to the manufacturer's literature.

We have tried to avoid recommending pigments, such as the Chrome colors, which carry a significant health risk. Toxic pigments such as Lead White or Cobalt Blue should also be avoided when making your own colors. In the case of colors such as the Cadmiums, however, there is nothing commercially available that matches them for color and permanence. But there is no danger in their use nor in that of other pigments, provided artists take sensible precautions.

Solvents are damaging to your health, so always keep the lids of solvent jars screwed on tight and use only as much as you need. The long-term effects from inhaling the fumes of distilled turpentine and white spirit include loss of memory, the inability to follow an argument, and paranoia.

A NOTE ON BRUSHES

The brush sizes given here refer to Winsor & Newton brushes. They may vary slightly from those of other manufacturers.

INDEX

ACKNOWLEDGMENTS

Author's acknowledgments

Ray Smith would like to thank Alun Foster at
Winsor & Newton Ltd. for his expert advice.
Thank you also to the many artists who agreed
to allow their paintings to enrich the book and
to the Royal Academy for providing valuable
assistance. Special thanks to everyone at Dorling
Kindersley associated with the DK Art School
project and in particular to my editor, Susannah
Steel, for her lively and enthusiastic commitment
to the text, and to Heather McCarry, whose flair
and judgment in the design shines through the
pages. Thank you also to Margaret Chang for her
great help with the picture research.

Picture credits

Key: *t*=top, *b*=bottom, *c*=center, *l*=left, *r*=right *a/w*=artworks

Endpapers: Jane Gifford; *pp8/9:* van Eyck, Rembrandt,
Ruysch, Tura, reproduced by courtesy of the Trustees, The
National Gallery, London; Titian, Isabella Stewart Gardner
Museum, Boston; *pp10/11:* Claude, reproduced by courtesy
of the Trustees, The National Gallery, London; Monet, The
Brooklyn Museum 20.634 Gift of A. Augustus Healy;
Cézanne, Louvre/Réunion des Musées Nationaux; O'Keeffe,
Collection of the University of Arizona Museum of Art, Gift
of Oliver James, ©1993 The Georgia O'Keeffe
Foundation/ARS, New York; ©Richter, Anthony d'Offay
Gallery; *pp16/17:* all, Ray Smith; *pp22/23:* Chagall,
Kunsthalle Museum, Hamburg, ADAGP, Paris and DACS,
London 1993; ©Gore RA, ©Sutton RA, Royal Academy of
Arts Library; *p26: bl* Ray Smith; *r* Jane Gifford; *p27: t* Jane
Gifford; *b* Ray Smith; *p28 t* Jane Gifford; *b* Ray Smith; *p29 t*
Jane Gifford; *b* Ray Smith; *pp32/33:* ©Levene RA, Royal
Academy of Arts Library; Frampton, all rights
reserved/The Tate Gallery, London, Nolde, Staatsgalerie,
Stuttgart, ©Nolde-Stiftung Seebüll/Arthothek Kunstdia-
Archiv; *p35 tl* Ray Smith; *tr, br* Trevor Chamberlain; *bl*
Lance Beeke; *pp38/39* all, Ian McCaughrean; *pp40/41 a/w,*
Jane Gifford; *pp44/45:* Kokoschka, Albright Knox, Atkins
Museum/Visual Arts Library ©DACS 1993; ©Jacklin RA,
©Weight RA, ©Philipson RA, The Royal Academy of Arts
Library; *pp50/51:* Hamilton-Fraser RA, Rooney RA, Royal
Academy of Arts Library; Picasso, Private
Collection/Visual Arts Library, ©DACS 1993; *pp56/57:* van
Gogh, Musée d'Orsay, Paris; Monet, reproduced by
courtesy of the Trustees, The National Gallery, London;
©Howard RA, ©Dunstan RA, Royal Academy of Arts
Library; Schnabel, Courtesy of Galerie Bruno
Bischofberger, Zurich, all rights reserved; *pp62/63:* Moroni,
The National Gallery of Ireland; El Greco, Metropolitan
Museum of Art, New York/Visual Arts Library; *p64:* Ian
McCaughrean; *p65: tl* Ray Smith; rest, Ian McCaughrean.

Dorling Kindersley would like to thank: Paintworks,
Cornellison & Son Ltd., and Winsor & Newton for kindly
supplying the artists' materials used in the book.